FORCE

FORCE

Animal Drawing

Animal Locomotion and
Design Concepts for Animators

Michael D. Mattesi

Visit me at
Drawingforce.com
Forceddesign.blogspot.com

Focal Press
Taylor & Francis Group

NEW YORK AND LONDON

First published 2011

This edition published 2015 by Focal Press
70 Blanchard Road, Suite 402, Burlington, MA 01803

and by Focal Press
2 Park Square, Milton Park, Abingdon, Oxon OX14 4RN

Focal Press is an imprint of the Taylor & Francis Group, an informa business

© 2011 Michael Mattesi. Published by Taylor & Francis.

Library of Congress Cataloging-in-Publication Data
Application submitted

British Library Cataloguing-in-Publication Data
A catalogue record for this book is available from the British Library.

ISBN-13: 978-0-240-81435-3 (pbk)

This book is dedicated to my parents and my parents-in-law,
for their support, kindness, and love…and to Zoe,
the family hamster; she was a great pet.

Special Thanks

In any endeavor, there are many great people behind the scenes that share in a vision and allow it to become reality. First and foremost there is my family. My ever-supportive wife Ellen and inspiring kids, Marin and Makenna. They consistently encourage me to follow my dreams and aspirations.

To Katy Spencer, my editor at Focal Press, who believed in the value of this book and who always responded exquisitely to my demanding emails and phone calls. Lauren Mattos, at Focal, thanks for supporting the cause. Melinda Rankin, the Senior Project manager on this book, thank you for your clarity and diligence. You helped me perfect the book in its final weeks prior to press!

Sherrie Sinclair, thank you for entrusting me with the students at The Academy of Art University in SF and for introducing me to Terryl. Thank you Terryl Whitlatch, you are invaluable as a friend and resource, keeping me on track with my anatomy and ideas.

To you, the reader of my books, whose growth and curiosity I love to feed with my epiphanies of our world, thank you!

Mike Mattesi

Contents

Foreword

Many students of animation are understandably challenged by the convincing portrayal of animals in motion. The sheer number of different species alone can make this task seem overwhelming. Yet, there are basic principles that, when followed, create a useful roadmap in negotiating this territory.

This marriage of biophysics, gravity, time, and motion can be learned and expressed in different ways. For some, like myself, it is an intuitive process, from a lifetime, beginning in earliest childhood, of unconscious yet focused and intense observation on what makes each animal and animal group special unto itself—the beauty first of all of the anatomy and then the beauty of that anatomy in action. All animals, from the tortoise to the tiger, have their own variation of dance. I was fortunate, through my parents and grandparents, to have been constantly exposed to animals of all kinds, from tadpoles to horses, nearly all of my life.

Not everyone, however, has that opportunity, especially in today's lifestyles where more people spend increasingly vast amounts of time indoors staring into digital screens rather than outside viewing reality, where animals live and have their being. Thus, there is a mental disconnect. What makes the cave paintings at Lascaux and Altamira so living and vibrant to this very moment is that those ancient artists abided in the animals' world and observed them every day.

It is absolutely essential to understand animal anatomy, and indeed, it is a lifelong vocation, if one is to become a successful wildlife artist and animator. But to take that anatomy and animate it, one must go that extra step. This book is a useful tool and guide in doing just that, breaking down motion and form into a formula that is easily grasped by both students and professionals alike. Rather than concentrating on anatomical subtleties, Michael distills the essence of motion and form, and how they work together, looking at the big picture of gesture and action, rather than the morphological details, which can be added later depending on the nature of the intended audience, project, or artistic vision.

Thus, this book bridges the gap, and the fact that Michael observed these principles in nature, whether in zoos, the countryside, or his own backyard, should likewise encourage all aspiring students of animal art, animation, and creature design to get outside and, using this volume as their guide, rediscover these delights, and the animal world, for themselves.

Terryl Whitlatch
October 31, 2010

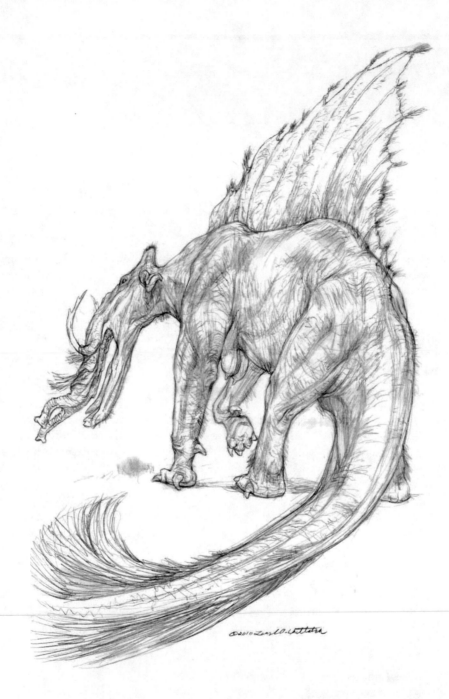

Design by Terryl Whitlatch

This is one of a number of concept sketches for a giant elephant creature, based on prehistoric proboscideans, and combined with a bit of sauropod and dimetrodon. She's alarmed by something, and has arrested her walk to swivel toward it. It must be something significant or unusual, because she has no natural enemies....

Preface

The photo above was taken at The Starlight Cafe in Greenville, North Carolina, in December of 2009. I described to my wife, Ellen, the secret sauce for this FORCE animal drawing book I committed to write. This was the first time I had put my ideas on paper. The sketches revealed to me that I had something new to share with the art community, and I was very excited to get started.

Here I am now ten months later, in my basement office—or what Ellen likes to refer to as my man cave—a little wiser to and more appreciative of the complexities of drawing animals. I have spent a great deal of time at the Oakland and San Francisco Zoos, visited Safari West three times, and spent numerous hours watching videos frame by frame from any channel that would telecast animal life. Let me humbly say, my first two books were MUCH easier to write and illustrate than this one.

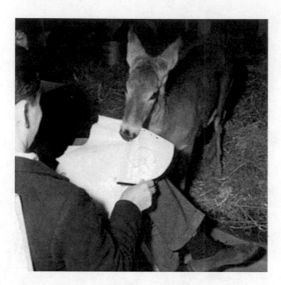

The above photo of Ollie Johnson, Walt Disney Feature Animator, presents the studio's dedication to studying from life. © Disney.

FORCE: Animal Drawing and Design describes how the abstract theory of FORCE relates to the animal kingdom! This book marks the third in the FORCE series and rounds out the library for drawing live subjects. The ability to draw humans and animals is a requirement for a portfolio to secure a job in the world of animation at the top studios. These present requirements are the same as sixteen years ago when I was accepted to Walt Disney Feature Animation. The question to ask here is "Why do Disney and other animation studios want you to be capable of drawing people and animals?" To help answer this question, let me begin with another question: "Why do we bother drawing a live human being in the first place?"

The answer to this question is … (drum roll) because you and I are human beings and, due to this fact, we can RELATE to the human model. We can understand physically what the model is experiencing because we are extremely similar to him or her. We understand how the model's body works, pulls, stretches, and bends. We understand that certain poses tell certain stories and represent emotions. A slumped-over pose with a person's hands covering their eyes usually depicts sadness. A pose with arms stretched straight above the head, fists clenched, and chest pushed out means triumph. Imagine Rocky Balboa reaching the top of the stairs at the end of his physical and emotional journey and then slumping his shoulders forward, bending his head down into his hands, and rejoicing in his accomplishments. We are so accustomed to what postures signify that we take for granted their universality.

How does this relate to the entertainment industry or, even better, to this book? Everyone else who spends money on the entertainment industry is a human being! So what? Well, other human beings are what you can most relate to, right? A film about motionless, expressionless rocks will not move you in a heartfelt, entertaining manner.

So why are there so many films with animals representing people? First off, many animal emotions are expressed using the same mannerisms and poses in which we humans express ours. My theory is that an animal is not a specific human, so more people can relate to the specific HUMAN emotions of the character without the need to see past the specifics of the character's facade. Sometimes tough subjects can be approached since it involves a character one step removed. We have in many ways humanized animals. These are some of the reasons why animation studios want to know whether you can draw humans and animals. Obviously, I did not know any of this when I was attempting to obtain a job by learning how to be the best draftsman I could be.

I am here to tell you I have come full circle in answering why I do it. I draw animals and people because I want to CONNECT to my subjects. I want to empathize with them in some deeper manner than just copying what I see. An amazing method of deeper expression is *FORCE*. Through this method, you learn to understand the abstract ideas of FORCE and how gravity, anatomy, environment, and many other factors affect the subjects you are experiencing. The method of drawing with FORCE will allow you to better experience the physical and emotional expression of your subjects, bringing you closer to their experience.

> "Our task must be to free ourselves...by widening our
> circle of compassion to embrace all living creatures
> and the whole of nature and its beauty."
> Albert Einstein

Here are a few reasons why this FORCE animal drawing book is unique:

1. You will learn how to draw animals through the theory of FORCE.
2. This book is organized by the different types of animal locomotive anatomy. That structure makes this the first book of its kind. Within each chapter, we investigate how FORCE, form, and shape affect that specific type of anatomy.
3. I take one revolutionary, simple animal shape based on FORCE theory and apply it to the different types of animal locomotive classes. This approach will simplify your outlook on drawing animals.
4. The last chapter of this book discusses a method with which to exaggerate animal designs.

Let's get started with some of my top-level, key concepts learned from the act of drawing.

KEY CONCEPTS

Fear

Since writing my second book, I have taught at Pixar and DreamWorks, and I am here to say that whether or not you are a professional, there is still fear to conquer! Fear is the most detrimental blockade to the forward pursuit of education. Fear comes in all forms, some more obvious than others. The top reasons for fear I have witnessed from myself and my students are:

1. Fear based on perfection. "My drawing has to be perfect. If it is not, then I have failed and thus I am a failure."
2. Fear of the teacher. "I hope I am doing the right thing."
3. Fear of judgment. "I don't want others thinking I am stupid."

The fastest vehicle out of fear is listening to your internal dialogue. Notice when and why you are indecisive or concerned. Allow drawing to be about your experience and curiosity, not the final product. YOU create the fear, so rid yourself of it! It will only slow you down. Remember, you are drawing, not jumping out of airplanes, hunting sharks, or living in the Depression, so fear nothing!

> "The greatest barrier to success is the fear of failure."
> Sven Goran Erikkson

Risk

To be able to grow, you must take risk, or what you perceive as risk. Risk to one individual is the norm to another. Be aware of that. Use your curiosity and passion for learning to push through your risks. This is where your courage and pride will come from. To have opinion, you MUST be able to take risk! You MUST move beyond your fears. You MUST be willing to fall on your face to pursue your creativity and become more than who you are today! Once you break the bonds of fear, and love feeling risk while you work, you will never turn back.

Opinion

Strengthening your ability to take greater and greater risks allows you to get out of the "kind of" mindset. New students look at life and "kind of" see it. You must see truth to form opinion. Opinions come from heightened clarity! Much of this clarity comes from knowledge. Your search for knowledge comes from curiosity. Don't draw with mediocrity. Strive for opinion through clarity. What are you trying to say? How do you feel during your experience of drawing the subject?

Use creative ideas when drawing animals. You might have a thought that is an analogy. Perhaps the animal's pose reminds you of a natural power, architecture, a culture, a time

period, a character, an automobile, or another famous artist's work. Draw upon your intuition to inspire your experience.

Vision and Empowerment

When I was in school, I would play games with my own mind. I would look at the model and then envision what my drawing would be on the page. My image of my drawing was far beyond my abilities at the time, but I do believe that the repetition of this activity allowed me to believe in myself and attain my goals more quickly. It is empowering to ask yourself if you are doing your best and answering honestly. You are capable of more than you are achieving. Hold yourself to excellence. I promise you that you will be amazed by your abilities.

Hierarchy

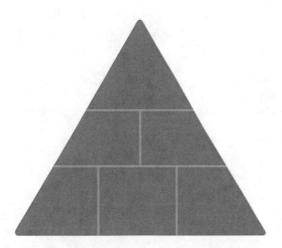

Thinking hierarchically, or from big to small, is a profound method to assess challenges. Hierarchy creates a clearly defined path and priorities that then assist in the comprehension of complex ideas. It seems to be human nature to initially resist this idea. We want to get mired in the details instead of seeing the big picture. Hierarchy is so profound that you can use it on anything, not just your drawing experience. It could be used to organize work procedures, your process for food shopping, the flow of automotive traffic, personal relationships, and more.

When you are drawing an animal, the whole pyramid represents the main idea of the pose or moment. Then within it, the top of the pyramid is the biggest idea, and the ideas get smaller as you travel down the levels of the pyramid. So, a pose is the whole pyramid: The top is the hip to ribcage to head relationship; the next tier is arms, legs, and tail; and then the last is hands, feet, fingers, and toes. As you get more sophisticated, the top of the pyramid might be the face and right paw because they best represent the main idea or story of a pose.

Contrast and Affinity

While I was working at Walt Disney Feature Animation, one of the best rules I learned was "CONTRAST CREATES INTEREST." Never forget that. Beware mediocrity through the lack of contrast. Look for idiosyncrasies. Watch out for symmetry, parallel moments, and monotonous line. This rule works for character design, landscape painting, film editing, writing, and all works artistic. Contrast is self-explanatory, but how many ideas can be contrasted? That is where the magic happens. A line on a piece of paper can have much contrast or little contrast. Is the line parallel to the edges of the paper, or is it at a forty-five degree angle? Is there variety in the weight of the line? How long or short is the line? Does it go off the page? All these possibilities represent different ideas in the world of art. Remember that every mark on the page has meaning, a meaning to create the bigger purpose of the artist's statement!

Affinity, or unity, means the similarity between items in the drawings. Now, with the animals, there is the obvious, such as two hands or two feet. In experiencing them, there can be patterns in shape, color, tone, line, and much more.

Design is an abstract way of looking at our world and using it to communicate our thoughts. Your art is only as powerful as your thoughts and how you communicate them with your skills. I hope to present you with some new tools to assist you in communicating your experiences.

Now let's get down to brass tacks: how to illustrate and experience FORCE.

FORCE: LINE IS AN IDEA!

As a refresher to some of you or a new concept to others, the idea behind FORCE is to comprehend and experience a live creature's energies created by its anatomy relative to the pull of gravity. In my first two books, *FORCE: Dynamic Life Drawing for Animators* and *FORCE: Character Design from Life Drawing*, I was focused on the functionality of the human form. In this book, we are obviously focused on animals. If this is your first FORCE book, this will be an exciting and new method with which to experience the life around you through the process of drawing. If this is not your first FORCE book, the new concepts on how to draw animals through similar processes you have been using with the figure will be enlightening and liberating.

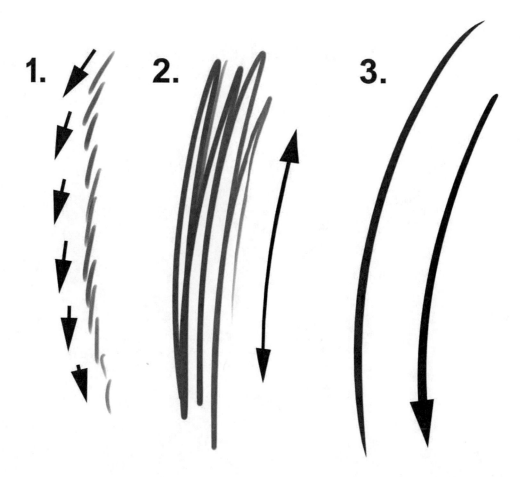

So, let's start with line. The preceding image shows three examples of line. The two on the left represent common methods of mark making with which an artist executes a line or, in my terms, the artist's idea. The lines you place on a page are a direct reflection of your thoughts and emotions—nothing more, nothing less. That is why the way in which you draw a line is SO IMPORTANT! Due to this point, the line on the right presents the FORCE line. It is one stroke that represents one idea. Example number one represents small thoughts and two is typically careless thoughts. Power lies in its clarity and meaning.

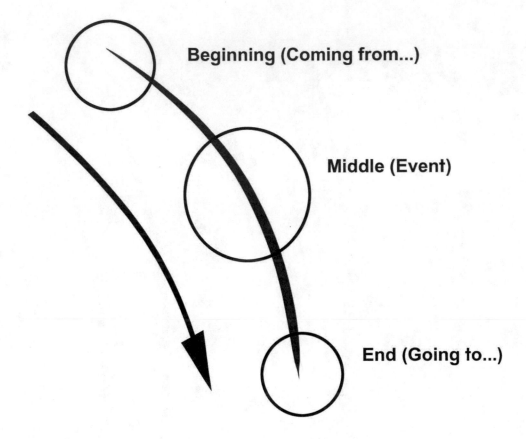

Beginning (Coming from...)

Middle (Event)

End (Going to...)

Directional FORCE

Did I say one idea? Actually, the FORCE line represents three ideas. That's right, three ideas in one darn line! Line can represent even more than that, but for now let's focus on the FORCE line's three main components. They are the beginning, middle, and end.

When you are thinking about FORCE and confronted with your subject, focus on a main event that clearly jumps out at you. That will lead you to feeling that FORCE by stroking your way into it, which is how you find the COMING FROM segment of the forceful line. Then you push your way through the event, feeling its power, and as you do, you look to see ahead where this FORCE is GOING TO!

I call this FORCE the *directional* FORCE because it directs FORCE from one location in the subject through an event to another location.

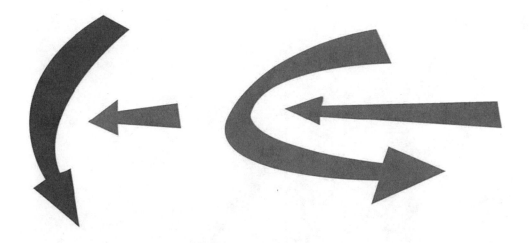

Applied FORCE

The vertical arrows in the preceding image represent directional FORCE. The horizontal arrows in the image represent *applied* FORCE. Applied FORCE directly affects the curvature of a directional FORCE. The image on the left shows a weak amount of applied FORCE. The small horizontal arrow, pushing upon the vertical directional FORCE, presents this. The directional FORCE on the left has barely any curvature; this tells you the applied FORCE was weak. You can take the same directional FORCE and add more applied FORCE to it from the side, as shown in the right diagram, and see how much more curved the directional FORCE becomes.

It is crucial to understand applied FORCE for a few reasons. When you are in the act of drawing a directional FORCE, the strength or weakness of the curvature of that line is dictated by the amount of applied FORCE driving into it. Also, the energy that you are about to apply to the next directional FORCE is decided while you are drawing the directional FORCE you are involved in at the moment. These two thoughts are the COMING FROM and GOING TO that we just discussed regarding the prior illustration. Whew, a lot to swallow. This will make more sense with the next illustration.

Rhythm

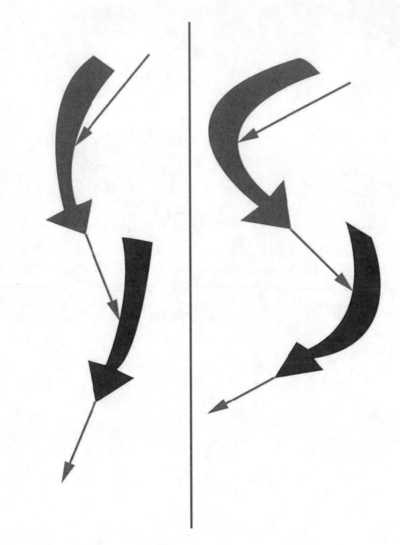

Rhythm is the act of one directional FORCE applying itself to the next. When you have two directional FORCES, you have one rhythm. The rhythm on the left side of the page is weaker, simply because the angles of applied FORCES represented here by the straight arrows are weaker. On the right, you can see an illustration of a more dramatic rhythm because the angles with which the applied FORCES approach the directional FORCE are much stronger, forty-five degree angles. Forty-five degrees is the strongest angle on the page. It is the medium between perfectly vertical and horizontal. If you want drama in your work, think about the forty-five.

FORCEFUL SHAPE

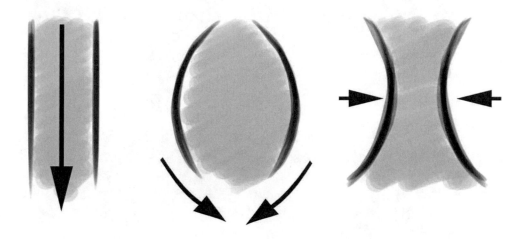

The Don'ts

The vast majority of this book will build on the premise of *forceful shape*. The FORCE lines create the shape. The way I like to discuss the forceful shape is by starting with what NOT to do. The preceding images show three examples of what NOT to do when drawing FORCE.

The image on the left shows two parallel directional FORCES that define this grayed-in shape. The issue with this shape is that we have two directional FORCES and no rhythm. This has to do with the symmetry created with the two lines. We have created something similar to a pipe. The black arrow here represents the vertical direction of FORCE with no chance of creating rhythm.

The image in the middle shows FORCE crashing into itself at the top and bottom of the shape. Again, this is due to symmetry. Two lines that create a shape like this sausage do not allow FORCE to bounce from left to right.

The image to the right shows FORCE equally squeezing into itself from both sides on this shape. This causes FORCE to get trapped within that shape. This again is due to symmetry. So what does all this information suggest? Do everything in your power to stay away from symmetry if you want to experience FORCE! If this is the case, what type of shape exemplifies FORCE?

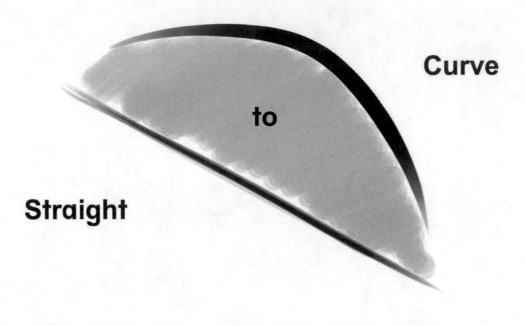

Curve

to

Straight

The shape above does: the straight to curve shape. The shape is asymmetrical. FORCE, represented by the curved line, simply moves through this shape and around the straight line to the next shape.

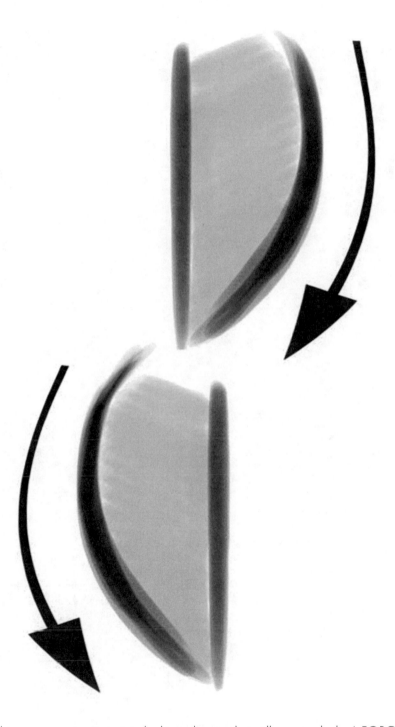

When this occurs, we attain interlocking shapes that still create rhythm! FORCE seamlessly slides from one shape to the next around the structural, straight ideas.

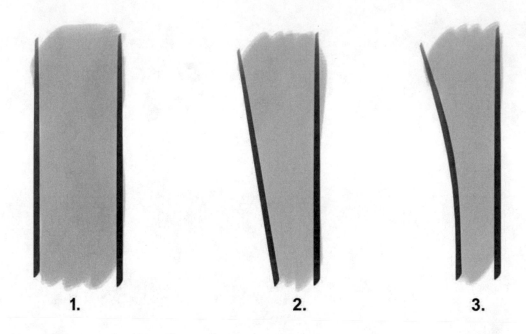

A challenge that transpires in drawing animals that does not in drawing humans is the great potential for parallel shapes. At first glance, this shape seems to occur most obviously in the unguligrade class legs (horses, giraffes, etc.). Your job is to look more closely and think about the function of FORCE in the shape. Here are some methods with which to do so:

1. This is an example again of two straight lines parallel to one another. This shape is absent of FORCE.
2. The way to add some FORCE to the shape is to angle one of the lines and create a more arrow-like shape. Although it is not as aggressive as the curve, you still retain a sense of energy moving down the arrow shape.
3. This last shape is an iteration on the forceful shape. The curved line here is concave though instead of convex. This shape occurs in animals due to the stretching of skin from joint to joint. Be careful not to overuse this shape because it can pull FORCE out of the animal design.

Returning to the concept of ONE LINE EQUALS ONE IDEA, stay on top of where one idea ends and another begins when designing shapes. In the above illustration, the line that runs along the left side of the shape is actually composed of three separate lines or ideas. Although it looks as though lines One and Two are one line or idea, they are not. Line One is a concave curve, and line Two is a convex curve. To draw from one directly into the other without recognition of this fact causes a disconnect from FORCE. The long line on the right side of the shape is the actual FORCE running through the page. This means that the lines on the left are there to support that concept. If the left side becomes too soft, the shape will fall apart.

So those are the basics of forceful shape. Let's take these principles and bring them to the three different locomotive classes of mammals covered in this book: plantigrade, digitigrade, and unguligrade.

Chapter 1
The FORCE Animal

There is only one anatomical structure to understand when drawing human beings. In the animal kingdom, there are many. This vast difference lead to numerous architectural iterations for the book. Other animal drawing books present their ideas on a per animal basis, but that did not make much sense to me. My focus was NOT to teach you, the reader, how to draw a bear or horse. I want you to leave this book with a broader understanding: FORCE in ALL mammals in a manner that would allow you to draw them with or without reference through the application of some simple rules. Since this book is based on the abstraction of FORCE, it made perfect sense to compose the chapters in the main three mammal locomotive classes. They are plantigrade, digitigrade, and unguligrade.

This approach was still not a simple enough manner with which to draw all mammals, so I dug deeper. My epiphany was that the main difference in these mammals is the adjustments made in their appendages or front and back legs, not in the trunk of their bodies. These changes determine how fast the animals move. In general, a plantigrade animal is much slower than a unguligrade, for example. These two animal types are designed to function against friction and gravity in two different ways.

My research led me to another incredible find, one that will change the way we perceive the animal kingdom and thus how we connect to and draw it. Join me now, through the step-by-step process I experienced to reveal this discovery.

Since I am not an animal but a human, I started with human anatomy and analyzed how it is different from an animal's. Always start with what you know. Let's go through these steps together to better help you understand my conclusions.

STEP ONE

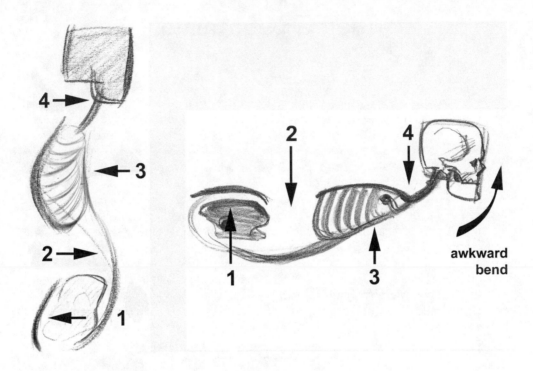

Let's start with the human body. For the sake of this lesson, I have numbered the **FORCES** in the diagram to the left to match those found in the diagram on the right. The main concept to focus on in the upright human is rhythm's functional design defined by a left-to-right motion. This motion is caused by gravity unfailingly pulling down on the human body. Our anatomy has reacted to this pull and therefore is designed to function with this invisible **FORCE'S** constant pull on us.

The image on the right presents the human body's **FORCES** horizontally. Basically, we have support against gravity in our hips and ribcage/shoulder regions. Our belly and neck/head areas hang from the supportive regions.

STEP TWO

FORCE Comparison between Man and Animal

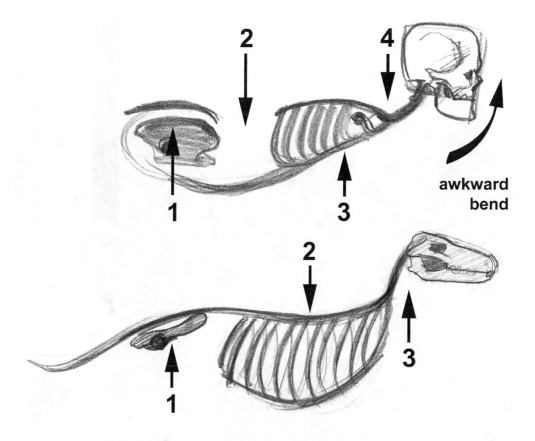

The human body is designed to stand upright. It has four major **FORCES** that balance out the masses of the trunk of the body. When this silhouette of **FORCES** is compared to an animal's, an interesting difference becomes apparent. The animal has one less directional **FORCE** than the human. Why does this occur? The rhythm of the animal is as follows:

1. There is an upward **FORCE** in the hips, similar to the human.
2. Then there is a downward **FORCE** in the human lower back. In the animal, downward **FORCE** occurs much further up the spine where the weight of the ribcage and all the animal's internal organs are pulled down by gravity. This difference will lead us to further investigation.
3. In the human, the third **FORCE** pushes up into the upper back, where in the animal we find our last **FORCE** pushes up the neck and head. So the **FORCE** that is missing in the animal is the upward **FORCE** in the shoulders and upper back. Let's take a closer look at this region of anatomy and figure out why this is occurring.

STEP THREE

Front View Cross-Section: Man-to-Animal Comparison of Scapula (Shoulder Blade) Movement

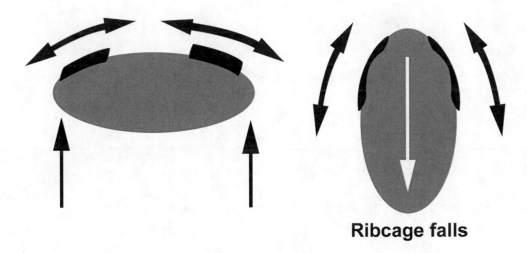

Ribcage falls

This image compares the shoulder blades on a human versus an animal.

1. The human's ribcage is in a more horizontal alignment. The blades slide left and right along the back of the body. They can also rotate to some degree on the back's surface.
2. An animal's ribcage is primarily vertical in its alignment. This allows for the blades to slide along the long axis of its ribcage. This also stops animals from stretching their forelimbs away from their ribcage, otherwise known as brachiating.

STEP FOUR

Skeletal Differences in the Shoulder Region

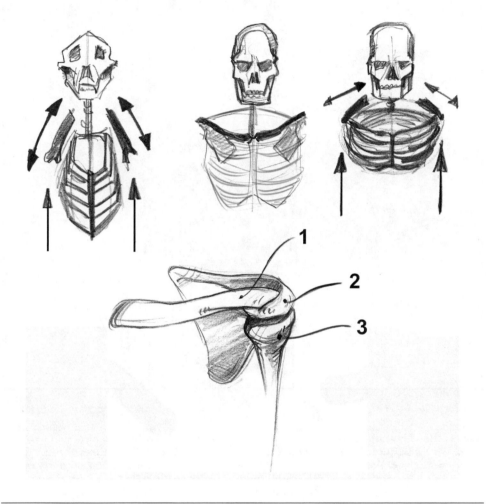

A few observations are of utmost importance here:

- Primates and humans have clavicles, or collarbones. The close-up image on the bottom presents that skeletally the clavicle (attached to the ribcage), scapula, and the humerus, or upper arm bone, all lock into one another. This is VERY IMPORTANT! Why?
- This image shows that if a human were to lie horizontally, similar to a push-up position, this position would affect him by skeletally supporting his ribcage and upper body because of the chain of structures we just discussed. This observation is important because if we remove the clavicle/collarbone, the scapula has nothing to attach itself to and neither does the humerus bone in the upper arm! Just to make my point clear, this means that all the weight in the front end of an animal's body is supported by the sliding scapulas and the muscles that surround them. When we, as human beings, do a push-up and position ourselves horizontally, our ribcage and internal organs are supported by the skeletal structure of the clavicle, scapula, and humerus! An animal does not possess this skeletal support!
- The ribcage and all the internal organs of the animal suspend from the two pillars of the forelimbs. This is crucial to the number of FORCES in our FORCE animal and where the FORCES are located.

THE BIG REVEAL!

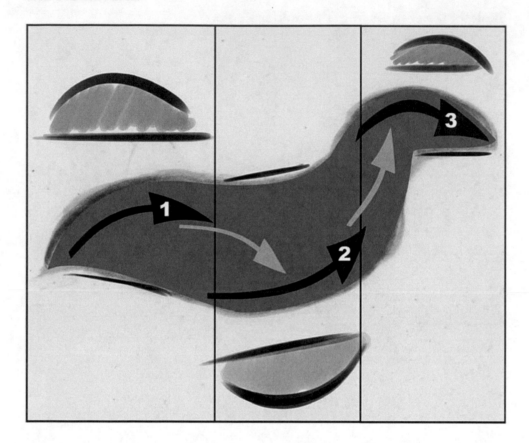

Here is the silhouette of our **FORCE** animal. This animal is what all others will evolve from. Isn't it beautiful? Perfect efficiency. The shape is broken down into three sections. Each section comprises a straight to curve shape that links up with the next one in the adjacent section. The orientation of this shape is called out with a separate illustration of a straight to curve shape. Let's discuss:

1. This area represents the upward **FORCE** in the hip region. This occurs here because the spine is attached to the hips. The bottom of the shape in this area offers a straight line to support the upward **FORCE**.
2. This section presents what we have been discussing for the past few pages. Area two represents the downward **FORCE** of gravity pulling on the animal's ribcage and organs. Here, the major change in **FORCE** compares to human **FORCES**. The straight line along the back shows the support needed to suspend the animal's weight from area one to area three.
3. The opposing **FORCE** found here lifts the animal's head through the structure of the neck. The more horizontal the animal's natural orientation, the lower on the skull the spine is attached.

FORM

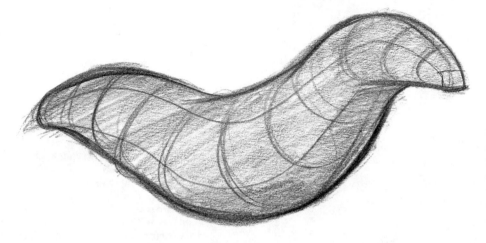

The image to the left integrates **FORCE, form, and shape to create the** *forceful animal.* **I threw a grid along its surface, clearly accentuating its form. Now you can see how it fills space.**

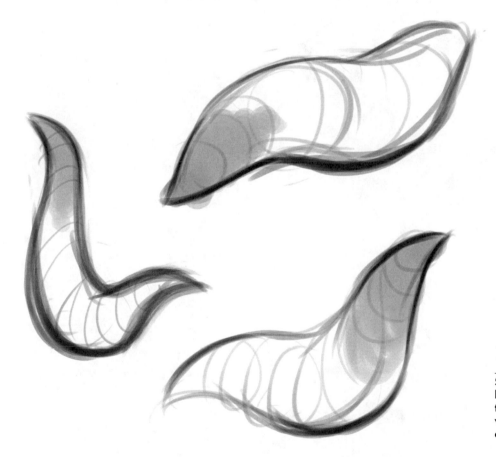

So let's test-drive this design a bit. The poses to the left present the FORCE animal shape filled with form. See the flexibility and form. No limbs yet.

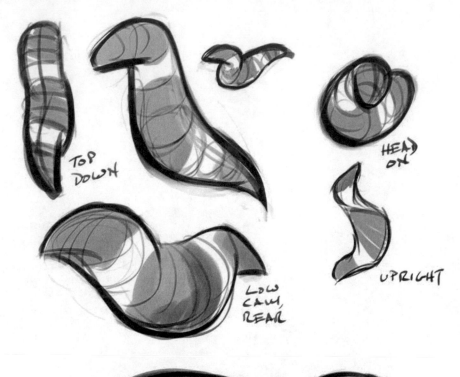

TOP DOWN

LOW CAM, REAR

HEAD ON

UPRIGHT

Just to add the slightest bit of anatomy, the preceding quick sketches of the FORCE animal show tone representing the head, ribcage, and the hip regions. Simple form and overlapping lines present us with perspective. These simple forms remind me of the first animal we will discuss.

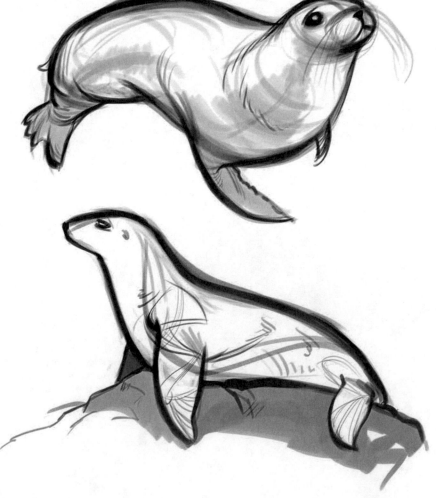

A seal! As I mentioned in my previous book, *FORCE: Dynamic Life Drawing for Animators,* "Learn to draw mammals by understanding the simple form of a seal first." The simple, clean shape of the body represents a great specimen for understanding the FORCE mammal. You don't need to get caught up in all the extra anatomy attached to the fore and rear limbs. Most of that anatomy is buried within the shape of the mammal's body.

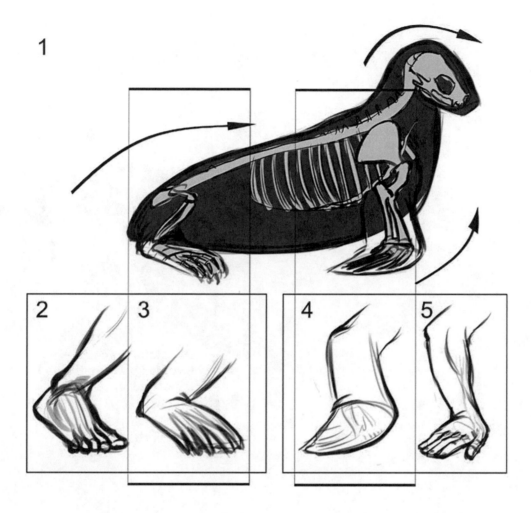

Here is our first animal-to-human comparison image. The comparison images are designed to clearly present a quick snapshot of many different aspects of the specific animal. This same layout will be applied to multiple animals throughout the chapters in this book. Following are the different areas and the information they present us with:

1. The silhouette of the seal based on our FORCE animal shape with the skeletal system found within the shape. Here, we will also find the three major FORCES that define the shape.
2. Human anatomy of the rear leg and foot to compare to the animal in question.
3. A pull-down image of the seal's rear limb compared to a human's leg.
4. A pull-down image of the seal's forelimb compared to a human's arm.
5. The human arm, used to compare to the forelimb of the mammal in question.

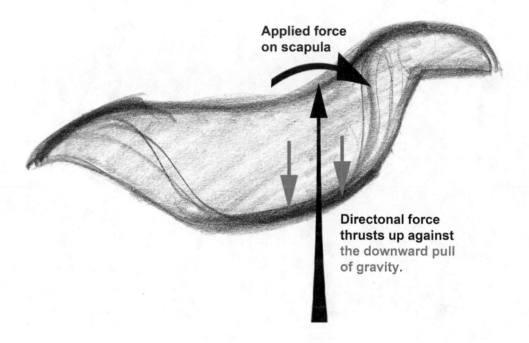

**Applied force
on scapula**

**Directonal force
thrusts up against**
the downward pull
of gravity.

When you're drawing animals, notice the cresting of the animal's scapula/shoulder blade beyond the top edge of the animal's body shape. This visual protrusion signals applied **FORCE** thrust upward by the vertical directional **FORCE** fighting gravity. This protrusion causes confusion among many artists between the scapula's upward **FORCE** and the downward **FORCE** in the ribcage. Yes, this upward **FORCE** in the shoulder region due to the lack of the scapula attachment to the collarbone creates a suspension-bridge-like schematic, but don't forget the drop of the ribcage sweeping into the neck occurring behind the scapula!

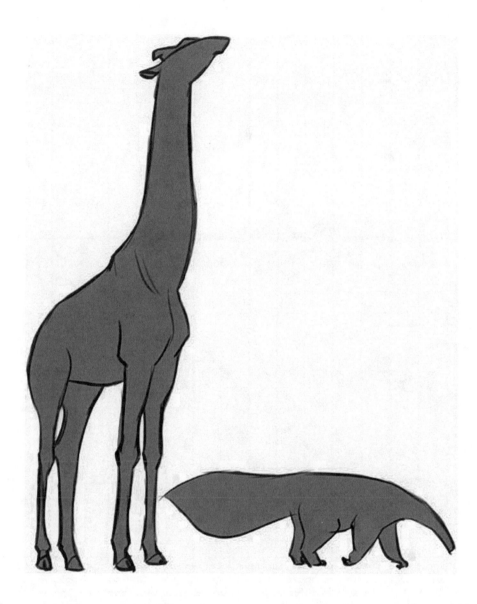

A clear example of this contrast in silhouette is a giraffe and an anteater. Giraffes eat the leaves off acacia trees. Because of this, they have a long neck and legs. Their scapulas are enormous, defining the large triangular shape of their bodies and supporting the heavy front end that they carry. The anteater, on the other hand, eats ants. Its short and stubby legs traverse over the landscape while its vacuum-like snout searches and sucks up food. Its snout curves toward the ground, not the sky. Its body silhouette, created by anatomy, derives from the animal's function.

The silhouette of an animal's trunk can drastically change based on the functional design evolved for today. The animal's environment helped mold the most efficient machines. The design of the animal's anatomy derives from eating habits and its methods of motion, protection, and hunting. This design comes from the environment: temperature, terrain, food source, and so on.

The animal's lung size legitimizes the animal's need for oxygen, which comes from its physical exertions. This size changes the silhouette.

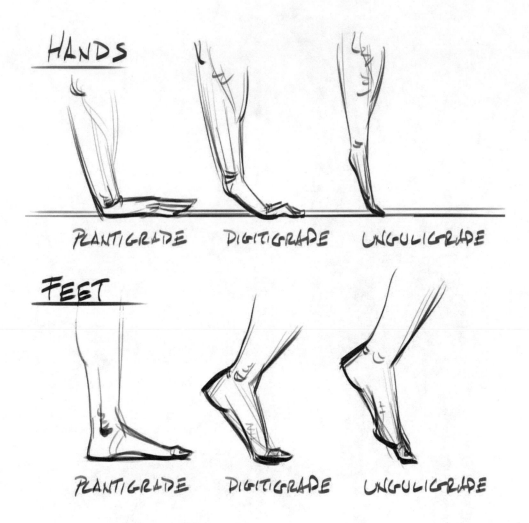

HANDS

PLANTIGRADE DIGITIGRADE UNGULIGRADE

FEET

PLANTIGRADE DIGITIGRADE UNGULIGRADE

Let's discuss the different grades of animals' locomotion, or walking. As mentioned previously, I will be using comparative anatomy throughout the entire book. So the above illustration shows the different grades based on human anatomy. This is how they function:

1. **Plantigrade:** These animals plant their entire hand and foot on the ground. Similar to a human being.
2. **Digitigrade:** The definition is that these animals walk on their toes, but I see it more as walking on the pad of the hand or ball of the foot.
3. **Unguligrade:** These animals walk on their fingertip or toe.

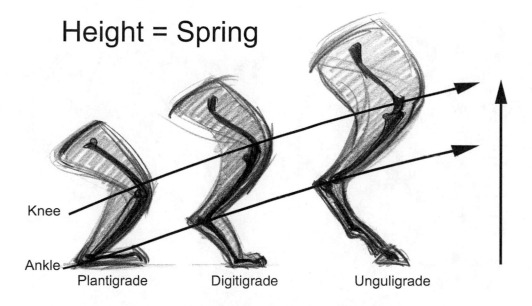

Height = Spring

Knee

Ankle

Plantigrade Digitigrade Unguligrade

The concept above presents the following finding: Height increase in the joints among different animals increases the springiness of the animal, the length of its stride, and thus the general speed of that locomotive class. Specific animals break this general rule, such as the world's fastest land animal, the cheetah. This cat lives in the digitigrade locomotive class and yet owns a top speed greater than any unguligrade class animal: A cheetah is a digitigrade and moves faster than a horse, an unguligrade.

Extension of front limb

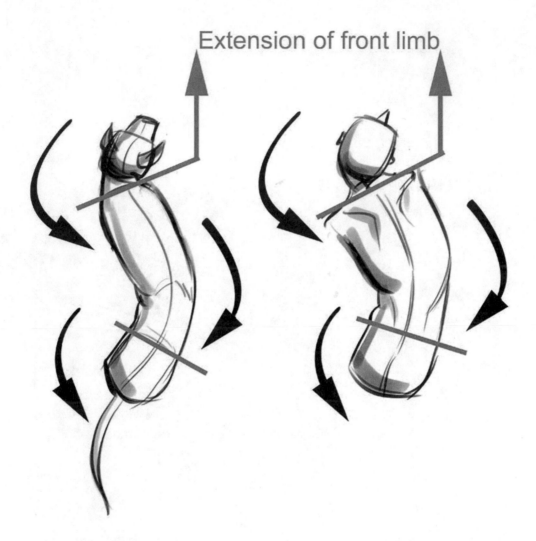

For an animal to obtain forward movement, two directions of FORCE must take place to create a third. One direction is vertical: The legs of the creature in question must lift off the ground to allow forward movement. The second direction is horizontal: The creature must move parallel to the ground. The image above shows how mammals move forward. Forward motion is achieved through the above rhythms in the body and head by allowing for a front limb to reach out into space. The rhythms set up a canter levering between the ribcage and hips. As a corner of the ribcage tips upward (relative to this image), the arm reaches outward.

Another way to describe this follows:

1. The ribcage tilts, as presented with the gray line and arrow.
2. This movement allows the forelimb to stretch forward.
3. As the ribcage tilts, so do the hips, allowing the back legs to operate.

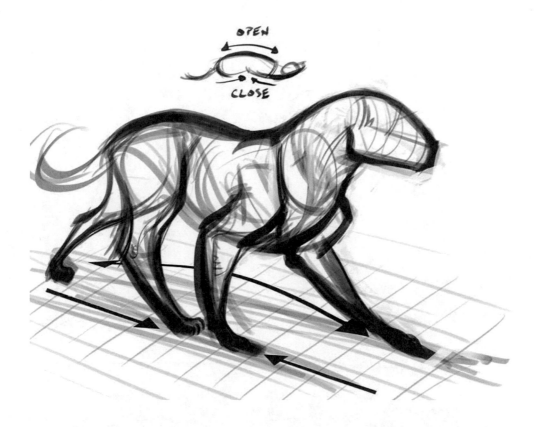

Let's add to the locomotive discussion with a simple observation. When a mammal walks, one side stretches open, and the other side compresses, or closes up the space between the front and rear limb.

While I was working at Walt Disney Feature Animation on *The Lion King*, a great concept shared among the animation team was this: When the back leg on a given side steps forward, it appears to kick the front leg on the same side forward. So, as the right rear leg closes the gap with the front right leg, it appears to kick the front leg forward. The rear leg replaces the weight the front leg was bearing by taking its place on the ground surface so the front right leg can now stride forward. This pattern occurs at opposing times on each side of the animal, allowing the animal's four legs to walk.

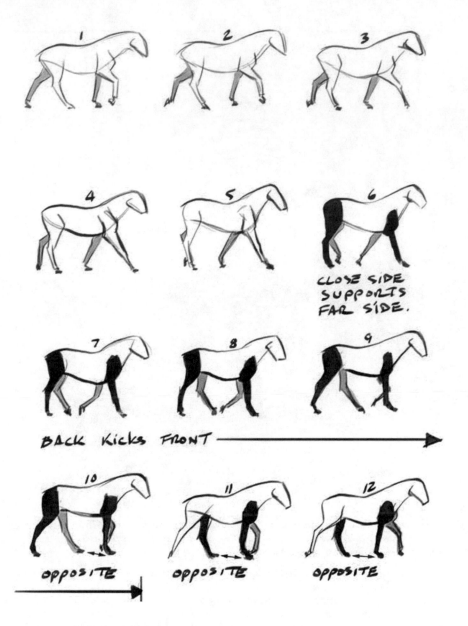

The above images present more information clearly illustrating a horse's walk sequence. I will use the word *far* for the appendages on the horse's left side and *close* for the horse's right side.

1-10 These images show how the far, rear leg kicks the front leg forward.

6 This image shows the ribcage and shoulder region at its lowest moment and the hip region at its highest. Also, the close appendages support the horse's weight, allowing them to move into their supportive positions.

9 This image shows the ribcage and shoulder region at its highest moment and the hip region at its lowest.

6-10 These images show how both legs on the close side support the weight of that transition. Something has to carry the weight!

10 There are three legs on the ground at this short moment.

11-12 Opposite legs bear the weight because the rear right leg now needs to kick forward the close front leg.

As the legs on one side are performing this act, the other two legs support the weight of the animal. This is the general manner with which all four legged mammals walk.

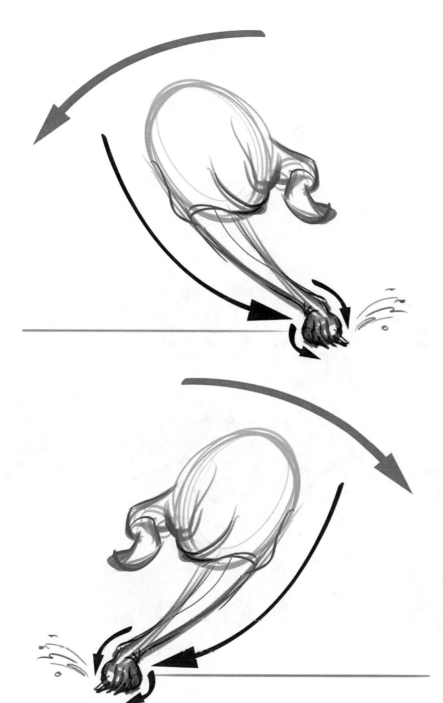

Here is an added interesting fact to keep in mind when observing a running animal. It has a lead foot, the foot that hits the ground first. That lead foot switches relative to the direction of a turn. For instance, if the animal in question is running and turning to the right, the right foot hits the ground first out of the front two feet. The left or outside foot is there for balance. The lead is taking the brunt of the animal's weight. Motorcycles operate in a similar manner. The side you lean on takes the brunt of the weight, and it is the direction the bike will turn in at high speeds. To add to the analogy, the back legs of the animal are its engine; the spring of the rear legs propel the animal forward while the front legs steer.

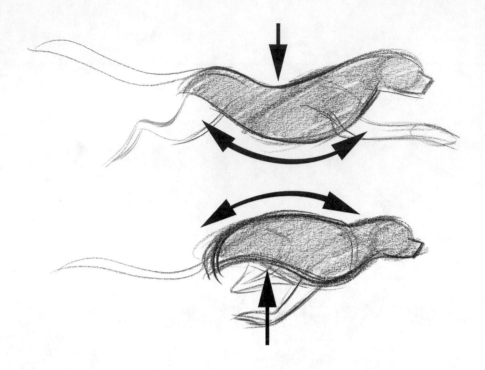

The animal silhouette displays its spring-like quality. When an animal runs, new locomotive patterns and movements occur throughout the body. The spine not only bends left to right, but on faster land animals also bends toward and away from the ground. The cheetah is an exaggerated example of this, as presented above. The bending of the spine permits the cheetah to stretch its limbs out further in front and behind itself than most animals, giving it tremendous reach and thus allowing for the cheetah to travel at great speeds.

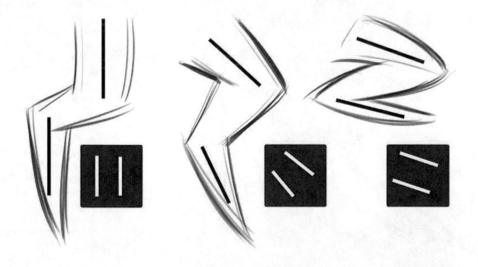

These three drawings present what could be either the fore or rear limbs of an animal. Within each gray box, two white lines show the angle of either the shoulder blade and forearm in the fore limb OR the thigh and foot in the rear limb. The point or trick I am stating here is, generally speaking, the angle of the shoulder blade or thigh is almost parallel to the forearm or foot.

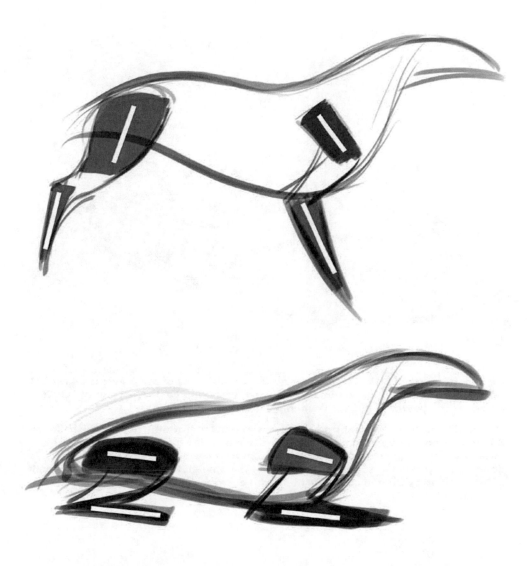

These two examples illustrate this observation in action. The top drawing shows an animal standing and the bottom, reclining. Look at the parallel presented in the relationship between the anatomies described earlier. At Disney, this was described as the *folding chair concept,* since a folding chair opens and closes with parallel bars with simple hinges connecting them. This is caused by the way the chair or an animal's anatomy is built.

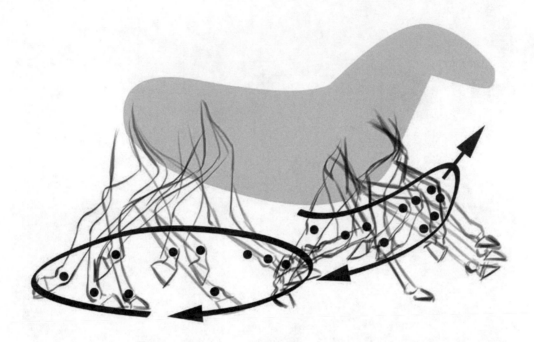

An important use of FORCE that I have not described in any of my previous books is its use at a higher level than within one drawing. In this image, the concept of FORCE describes the power found within multiple moments or drawings.

The FORCE paths of the front and rear limbs of a horse track the first joint (similar to the ball of the foot on a human and the wrist joint in the forelimb). The path of the forelimb possesses a strong peak at the top of its movement before the leg snaps down to the ground to support the weight of the animal. This is seen within the path of the right arrow. The elliptical rear leg path describes motion with less shape contrast.

This chapter, the most important in this book, defines FORCE and its relationship with animals. Please read and reference it numerous times for a full understanding of what lies within its pages. Your level of understanding determines your success with the following chapters.

Chapter 2
Plantigrades (Slow Land Animals)

Examples of plantigrade animals are prairie dogs, raccoons, opossums, bears, kangaroo, weasels, mice, pandas, rats, squirrels, skunks, and hedgehogs.

BEARS

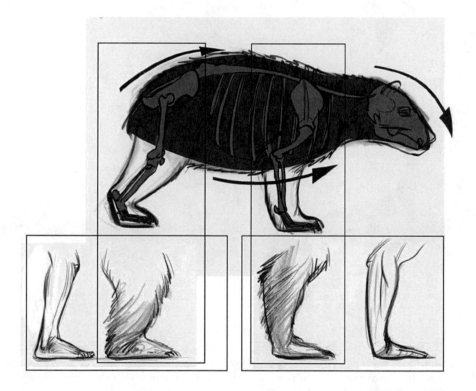

Here is a basic profile view of a plantigrade mammal—in this case, a bear. Keeping in mind all that we discussed in Chapter 1, remember that the shoulder blades are **NOT** attached to the ribcage in any skeletal manner, but the hips are. That gives us our **FORCE** mammal shape. Then I have superimposed on top of that shape the rectangles that align with the extruded fore and rear limbs of the bear, and next to each limb is the human anatomy counterpart. In short, you can see how identical the two are.

The similarity in proportion and anatomy to humans makes the plantigrades the easiest of mammals to understand and therefore draw. With all animals, pay attention to where the knee, elbow, ankle, and wrist joints land between the bottom of the body and the ground.

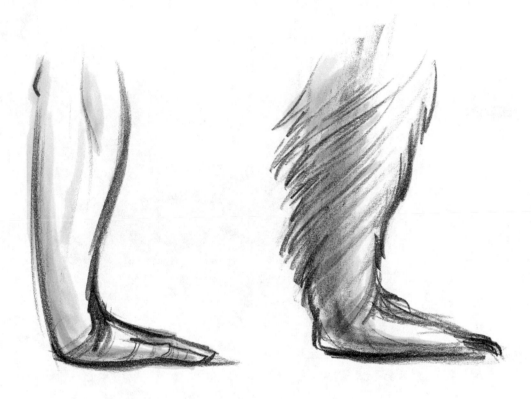

This image shows a side-by-side comparison of the hand of a plantigrade mammal. The similarity here is the closest of all the animal locomotive classes we will cover in this book. The front paws of these mammals basically operate in the same behavior as human hands.

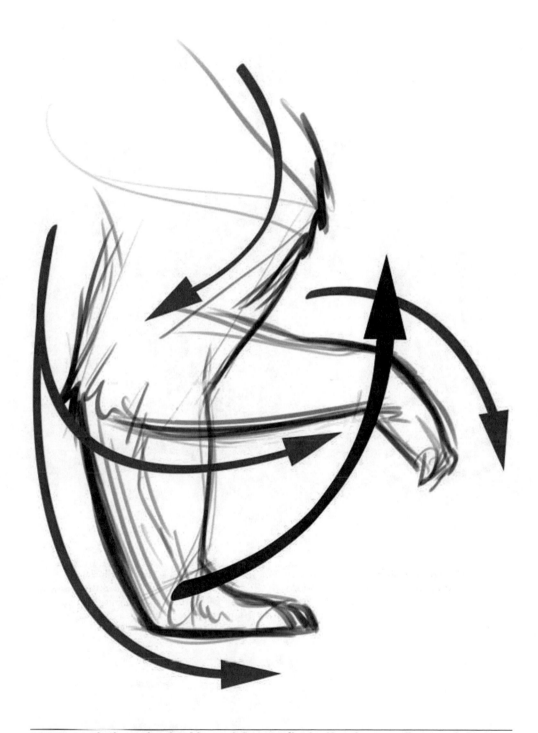

FORCE travels down the shoulder and then applies itself to the rear elbow and down to the wrist. When the plantigrade bends the wrist, FORCE will apply itself across the forearm to the top side of the wrist, creating another rhythm, as demonstrated above.

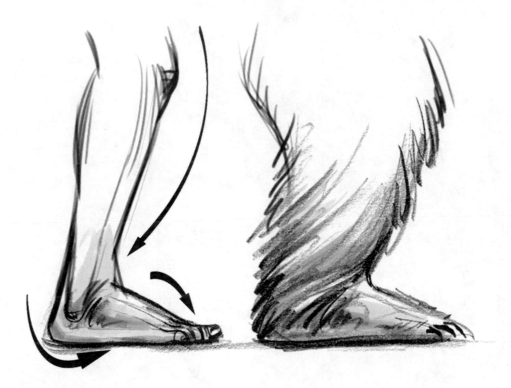

The plantigrade foot is also extremely similar to ours. The knee is typically not in a locked-back position, so **FORCE** drives down the front of the entire leg and then applies itself to the back of the ankle. This new directional **FORCE** then moves over to the top of the foot, where it then moves to the ball of the foot and out the toes in smaller rhythms.

Grizzly Bear

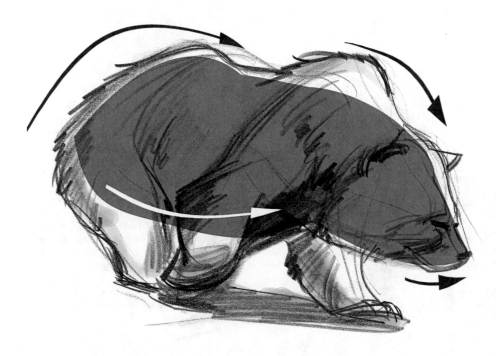

This grizzly bear is in the middle of a brisk walk cycle. Notice how the fore and rear legs are close together, and on the far side, they are apart. If we return to the thought of the back leg kicking forward the front leg of the same side, the bear's right front leg just got kicked. That is why it is up in the air and making its way to a location in front of the bear. I have also illustrated the FORCE shape of the grizzly and presented the three main movements of FORCE in the body and the small one for the upturned front of the muzzle.

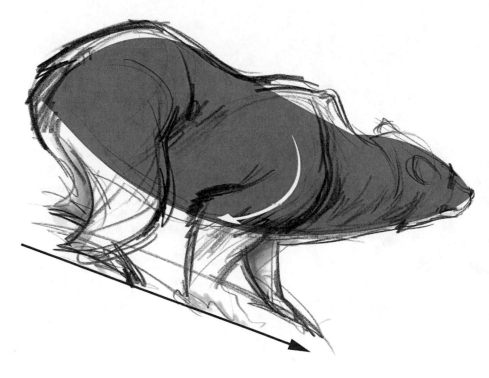

This bear divulges his struggle with gravity through the amount of FORCE presented in the shoulder. As you can see, the downward slope where the bear stands causes all the bear's weight to be thrown to the front end of his body, especially the shoulders. The bear fabricates a brace-like structure with the front limbs, while the rear limbs attempt to resist the slide down the slope.

Observe the FORCE shape to assist in understanding its previously described relationship to the front and rear limbs. The elements combined give us an image of effort based on the bear's surroundings.

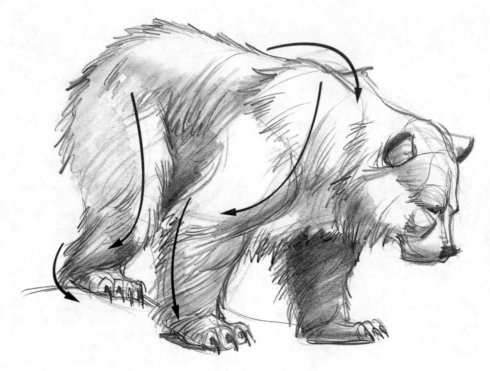

The name *grizzly* comes from grizzled or gray-haired. This characteristic is one that separates the grizzly from other bears. In the image to the left, I have called out the **FORCES** of the front and rear limbs. Notice the length of the **FORCES** of the front leg. Their beginning is up in the shoulder blade. **FORCE** then travels down into the shoulder, where **FORCE** transfers itself over to the back of the forearm, creating a rhythm.

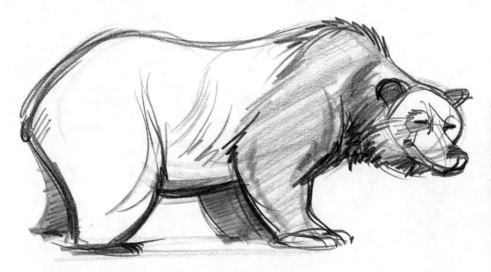

My favorite moment in this drawing is the weight captured at the bottom of the ribcage and start of the belly. I hope you can see the suspension of that weight supported by the hips and then the shoulders. Remember that the stomach **FORCE** sweeps up to the top of the neck. I added some character to the grizzly's face, pushing its long, curved snout.

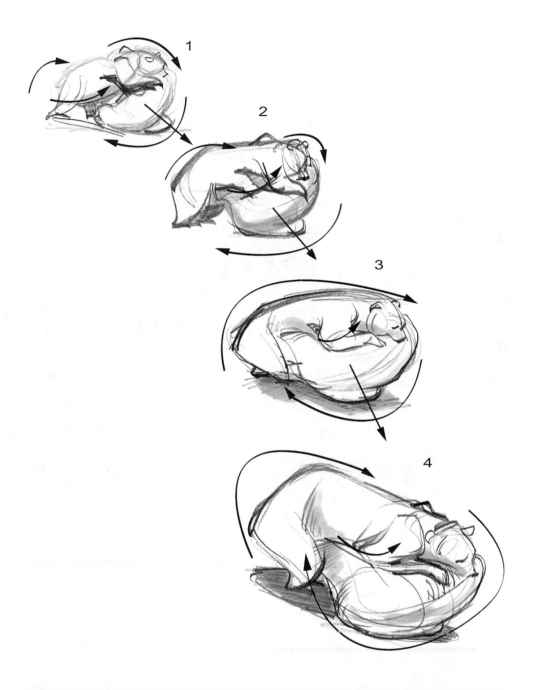

Here, two male grizzlies are playing with each other. The grizzly with the upper hand is hierarchically at the top of the pyramid in their relationship, and this image again proves why. The transition from image to image provides the process with which the king grizzly overpowers the younger one. Notice the change in angle of the arrow furthest at the bottom and how it moves in a clockwise direction, presenting the change in applied FORCE from the top bear.

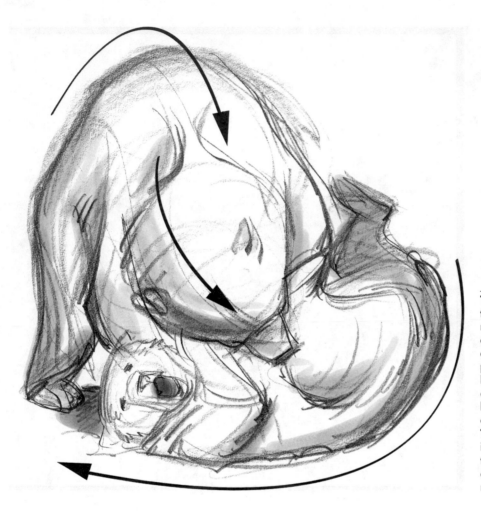

This image shows the same two bears with the finishing move. The FORCES of the bears as a relationship to one another bring us up the pyramid of FORCE. Now you are looking at the relationship of directional and applied FORCE between two animals instead of FORCES found within one. The FORCE of the upper grizzly is pressing itself down against the other. This is a simple example of action and reaction.

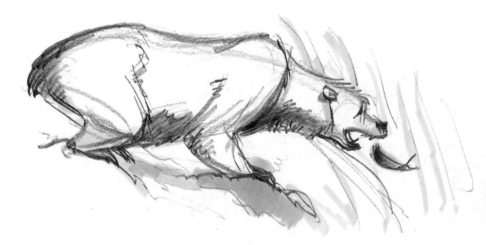

Fishing for salmon, that's what grizzlies do best. This guy is just moments away from enjoying his meal. Look at the compressed FORCES in the front and rear legs, poising the bear for his catch.

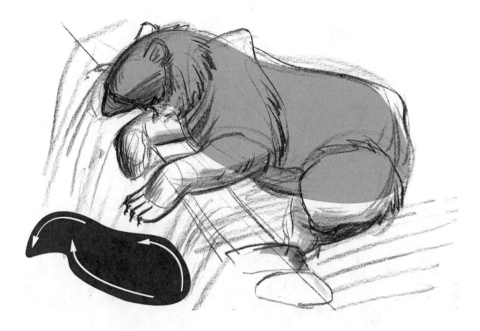

This grizzly sits at his leisure above small falls, enjoying the cool spring water. I have extracted the bear's **FORCE** shape for your convenience. You can see the three main **FORCES** found within that shape. The bear's face looks similar to an arrow at the peak of the shape.

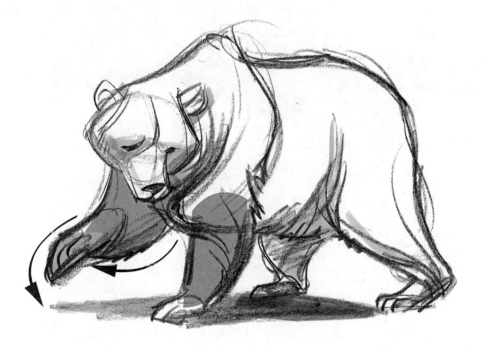

The bear's left front leg supports the weight of the upper body, which is why you see the effect of this in the protruding shoulder blade. Using straight to curve concepts, I have added design to this drawing. See the shape in the close fore leg and the far front paw. Simple straight to curve shapes create an elegant rhythm as the bear prepares for its next step.

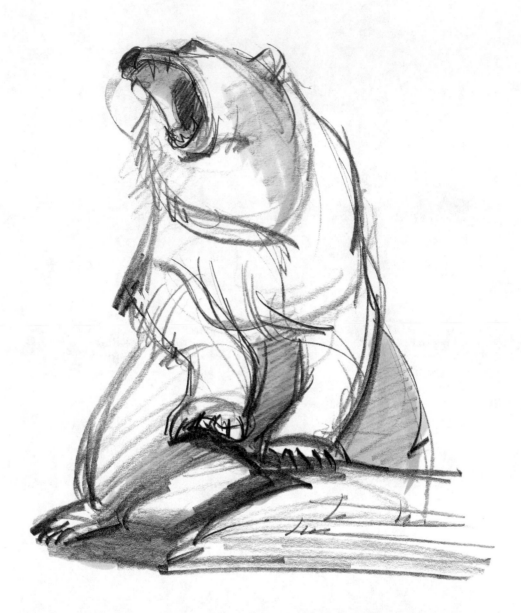

The grizzly is one of the larger brown bears. This guy was standing around that eight- to nine-foot benchmark and not looking too happy. The one area that I brought particular attention to was the wrist on the left side of the image. The bear's body is a large arc sweeping to the left.

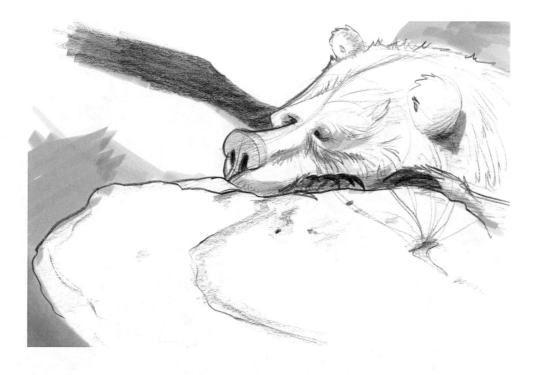

This illustration shows a design of the grizzly bear's face. The way I think about this is to take what is core about the grizzly and push it far enough in my mind to react to it and make it core in the design. When I look at this image, I see that the eyes are small, and the muzzle is long with a sweep. The nose itself is quite large. The story represents resting and calmness. I also used a branch-like shape to bring you right to the grizzly's eyes.

I like the dense, black claws against the soft, furry face and the size difference I pushed between the ears to give the image depth.

Alaskan Brown Bear

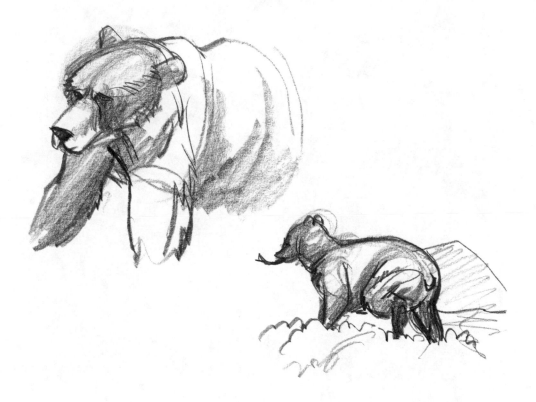

Above, we have a close-up of an Alaskan brown bear and another, fishing for salmon along the top of a short waterfall. During the experience of drawing the bear in the top-left corner, I thought about the large dish-like head top, the steep plane of the eyes and cheeks, and the long, boxy snout. The fishing image was a fun moment to capture. I like the manner with which the bear joyously walked toward land to eat his catch. I tried to capture the compression of the back leg as he walked away.

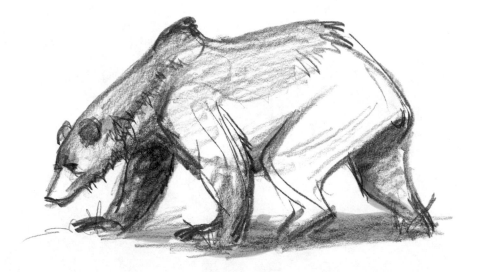

These Alaskan brown bears are large! They can weigh upwards of 1,500 pounds and stand around nine feet tall. Their large, muscular humps allow for some great digging prowess.

The browns, grizzlies, and Kodiaks are basically the same except for their locations. Due to their habitats, their size slightly varies. The Kodiak lives on Kodiak Island, where the bears have an abundant food supply and barely any predators.

Notice the obvious resemblance of the rear leg to one of a human. Again, plantigrades are some of the easier animals to draw due to this more direct comparison to human anatomy.

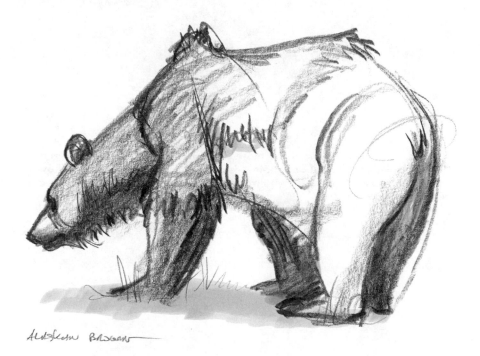

The rear legs in this image look more like a human's than the previous drawing did. This bear has huge arms and shoulders to endure his weight. The long fur near the shoulder blades, neck, and head resembles a lion's mane.

Polar Bear

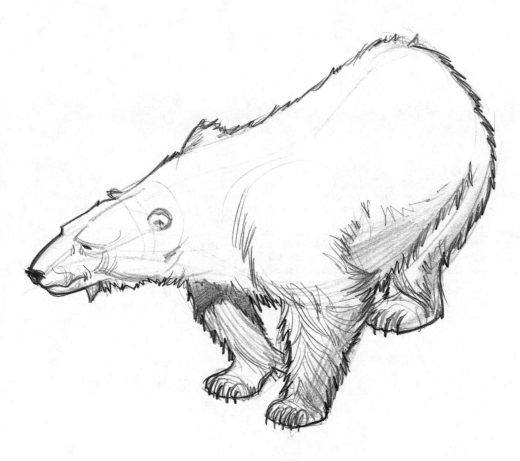

The longer the fur of the mammal, the more challenging it is to experience that mammal's locomotive, forceful design. In this drawing of a polar bear, see how we sweep from the top of the rear, down through the abdomen, to the top of the brow that then slopes down its face.

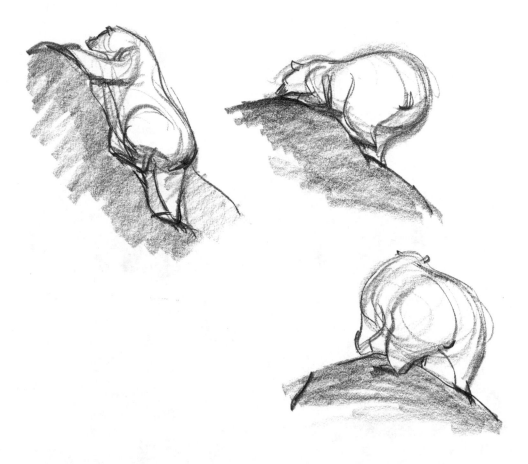

It was amusing and intriguing to watch this thousand-pound polar bear climb up a rocky slope, moving its weight with a sense of ease. The success of the climb depended on how well he could handle all the weight in his rear. The second drawing shows the bear pulling himself over the rocks for leverage while getting his rear up the slope. The polar bear does this all within the comfort of his fur. The outer fur of the polar bear is called guard hair, and it is hollow, allowing for excellent insulation! Due to the mammal's insulation, infrared cameras can barely pick up the heat signature from the bear.

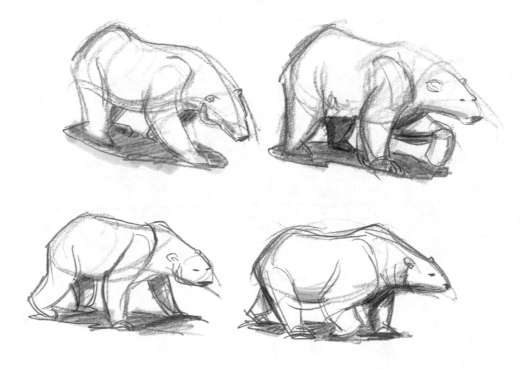

The polar bear walks like all others by kicking the front leg forward with the rear
leg to walk and sustain his weight. Scientists have discovered that polar bears are
descendents of brown bears. Their necks and snouts lengthened over time due to
their environment and prey. The change in their anatomy allows them to break
through the ice and surprise their favorite meal, the seal. They have large, padded
feet that allow them to comfortably walk on the ice and swim well. The paws have
short, sharp claws to assist with the terrain also.

RACCOONS

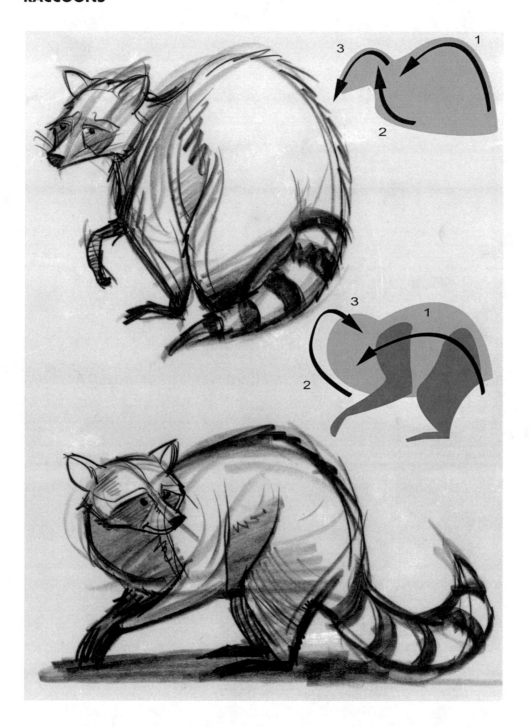

The top raccoon shows us the FORCE shape in depth with the three main FORCES defining rhythm and design. In the lower FORCE schematic, something interesting happens. FORCE moment two runs into number three because of the angle of the raccoon's turned head.

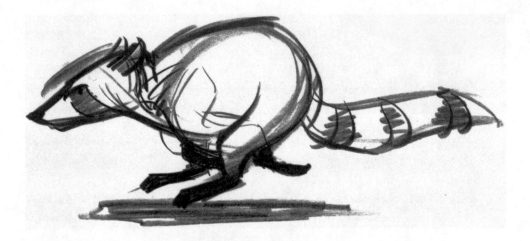

Here is a raccoon bolting from a predator. See how the **FORCE** of the back sweeps its way down into the legs. You can see my preliminary sweep of **FORCE**. Then from out of this **FORCE**, we move into the chest and up to the top of the head rhythmically.

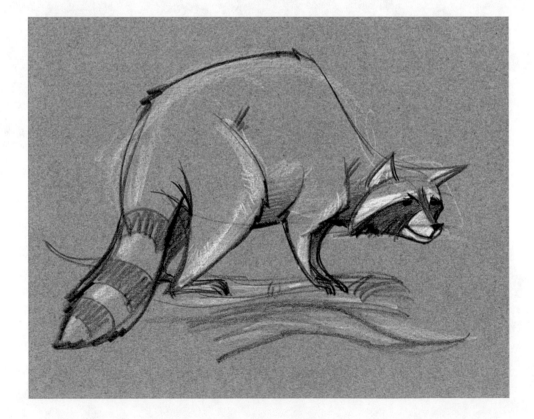

Here is a more stylized version of the raccoon. I pushed the height of the back and the simplified shapes of the front and rear legs.

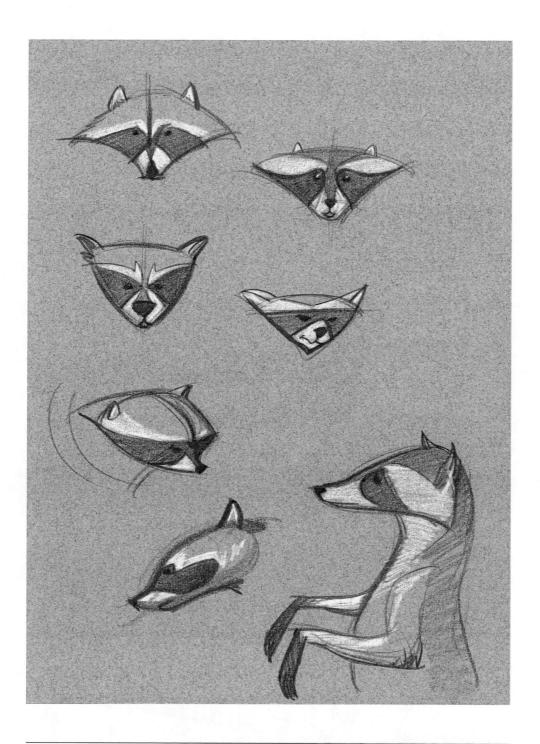

Since the raccoon wears an iconic mask-like shape on its face, I thought I would play with it as a design element. The first few images at the top are frontals investigating the shape of the head relative to the mask. I then decided to see how the mask would fit in a three-quarter view. In the design of the raccoon looking to the bottom right, I clarified the large flat top of the head and the small quality of the snout. The last design in the bottom-right corner displays my thoughts about his head and hands' shapes. I adjusted their length and width.

KANGAROOS

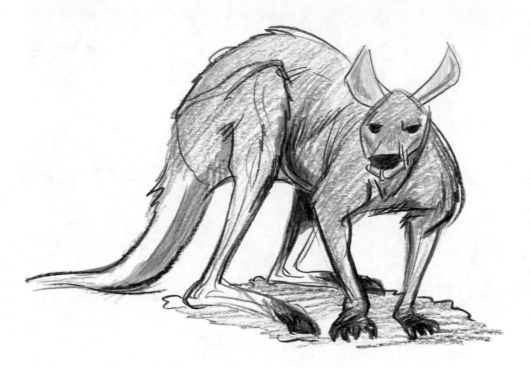

The kangaroo body is basically a straight to curve **FORCE** shape. That shape is cradled by the hip structure and the large plantigrade feet. When it comes to the forelimbs, this mammal closely resembles humans.

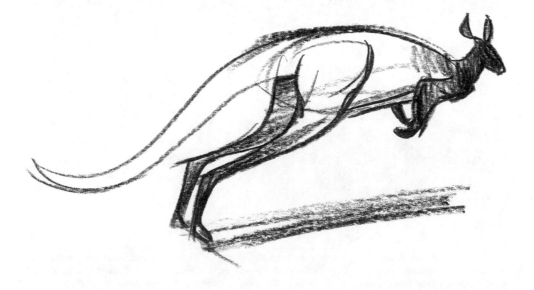

The reach of the rear legs on the kangaroo is astounding. This impressive reach is what allows it to perform such great leaps and surpass speeds of forty miles an hour. Here again, you can see the clear **FORCE** shape of the body.

RODENTS
Rat

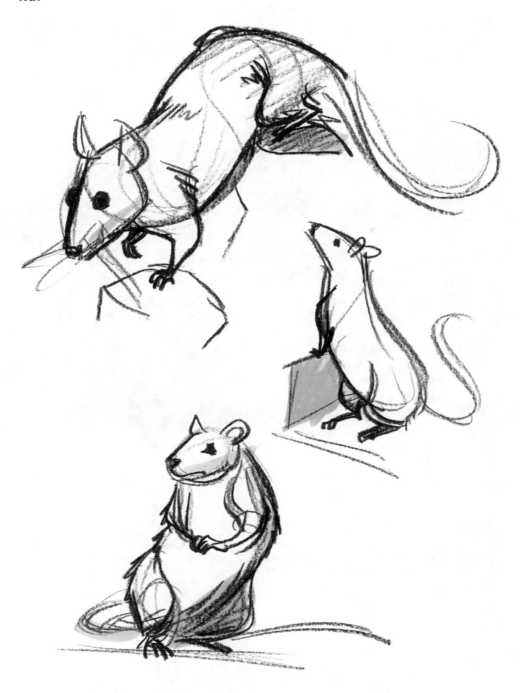

Yup, rodents belong to the plantigrade class of mammals. They basically run around on their flat hands and feet. Similar to a seal, they have simple streamlined bodies and are great animals to draw to further understand simple forceful shape.

Squirrel

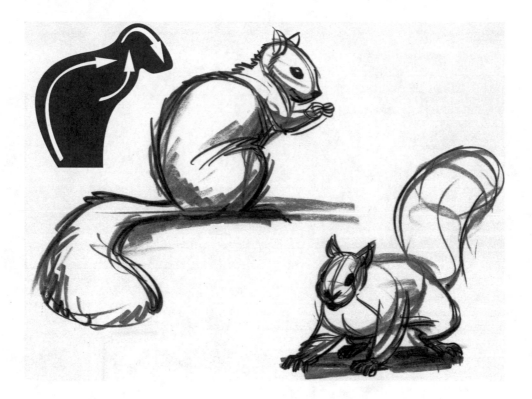

Here is another common plantigrade, the squirrel. The top-left corner shows the forceful shape found within the squirrel's body. I also added the three main **FORCES** that define that shape. The bottom squirrel has much foreshortening, but if you keep in mind the main three **FORCES** and the **FORCE** shape, overlapping moments will define the forms.

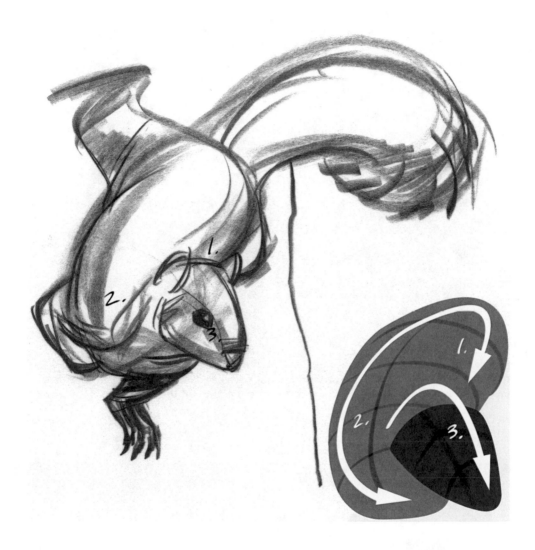

The claws of the squirrel allow it to easily scale trees for food and protection from predators. This guy supports practically all his weight with his one front leg while the other is poised for its next step. The tail is used for further balance.

The bottom-right corner shows his forceful shape. The numbers call out the three main **FORCES**. Because we are looking at the squirrel from the top, and he is bending, we can attach the first **FORCE** to the second. The second then hooks up with the third, which represents the **FORCE** of the neck and head.

On top of the shapes, I defined the forms with a few curved lines to fill the shapes with structure.

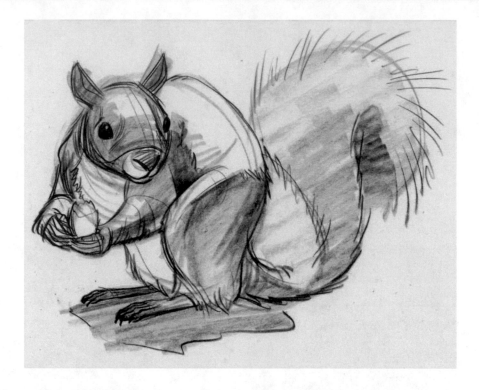

This image follows all the rules of the previous two. I added some tone to further pronounce the architecture of the leg and the roundness of the head.

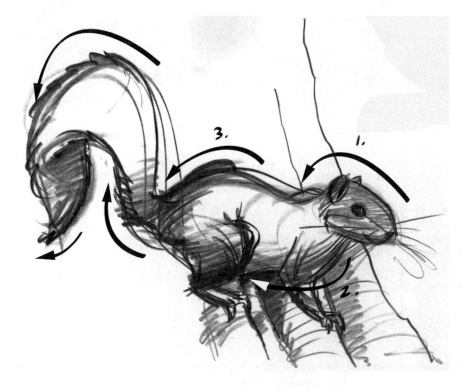

The squirrel's main FORCES are called out here in this profile image. There are more FORCES that guide their way through the long, rhythmic tail.

Prairie Dog

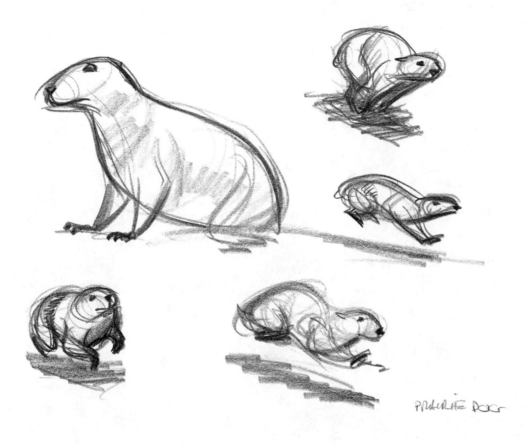

The prairie dog is a fun animal to experience. The simple FORCE shape and short-haired coat make the visuals easy to understand. It is similar to the flour sack on all four legs, running, jumping, squashing, and stretching.

LIZARDS
Komodo Dragon

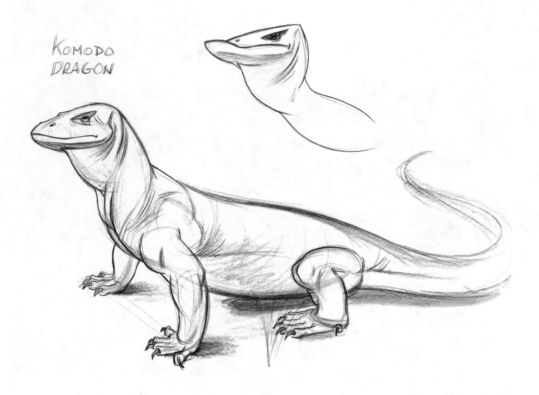

KOMODO
DRAGON

I threw this guy in here so you know that lizards are also plantigrades. All the other animals in this book are mammals. This one guy is a reptile, but he is also a plantigrade, so when you're drawing reptiles, keep in mind the FORCE rules applied to the plantigrade class.

PRIMATES

Gorilla

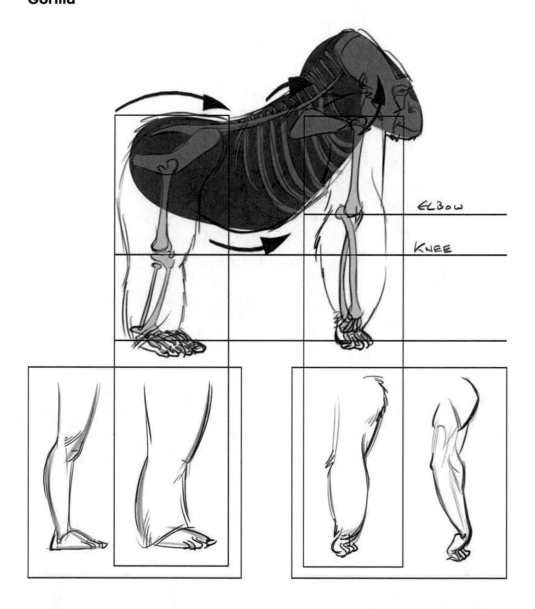

ELBOW

KNEE

I cannot leave the plantigrade chapter without recognition of primates. The gorilla does NOT work with the FORCE animal shape due to the fact that primates have a collarbone. At first glance, you might think they look like a human walking on all fours, but they are quite different. They lack the "S" curve found in our spine that allows us to walk upright. Also, if we were to walk on all fours, due to the length of our legs, we would point downward, and this angle would cause great strain on our necks. Primates are not born to run on all fours as are the other grades of locomotion found in this book. Primates have numerous classes of motion: arboreal (climb on top of branches), suspensory (hang onto branches), leaping (jump from branch to branch), and terrestrial (walk on land). The size of the primate provides a quick and simple manner with which to determine which class it falls into. Smaller primates are arboreal, and the larger ones are terrestrial. Gorillas are terrestrial.

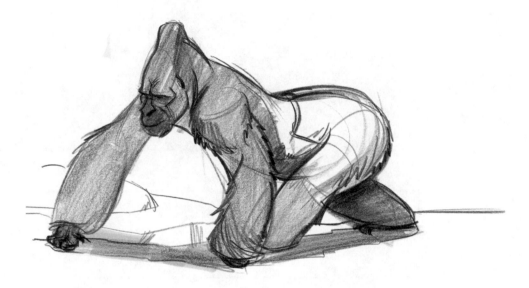

Subtle anatomical changes within primates make it more efficient for the gorilla to walk on its hands and feet than us. Gorillas are known as knuckle-walkers since they walk on the knuckles of their hands. This allows gorillas to possess long fingers for climbing but also a manner with which to walk on their hands. This gorilla is capable of walking on its rear legs awkwardly.

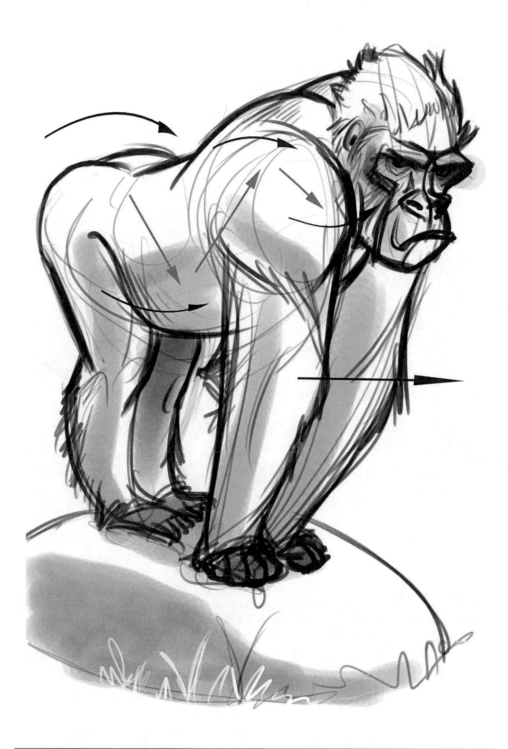

Gorillas' elbows hyperextend, so watch for this incident in the gorilla walk cycle and when they are standing on all fours, as seen above. This is a somewhat abnormal event to humans and other animals. Black arrows in this image represent directional **FORCE**, and the gray arrows are applied **FORCE**.

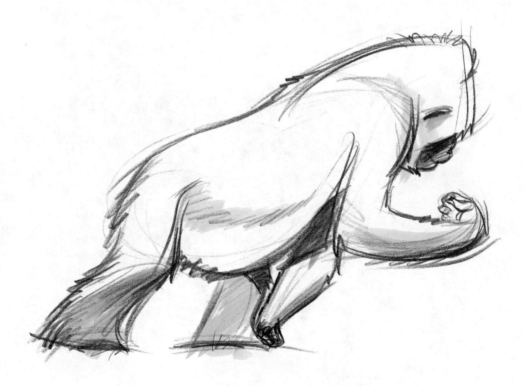

Aggressive shapes construct this speedy pose, sweeping us up to the hand–face relationship. A wonderful story lies within the highly charged negative space. What is the gorilla thinking? The arm and leg on the far side act as a brace, allowing the gorilla's close side to be as open as it is for a longer period of time.

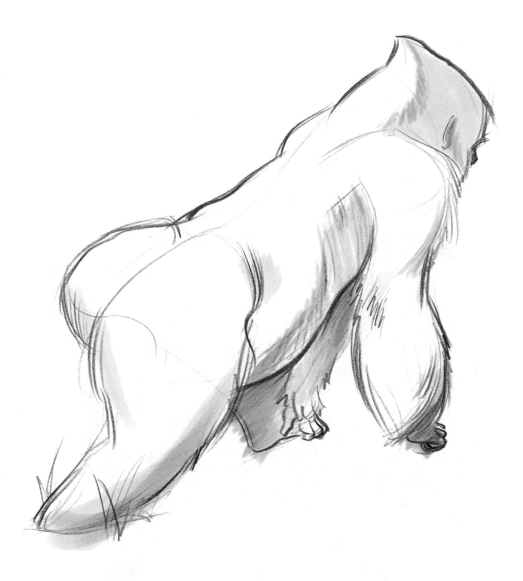

Notice the hump at the base of the neck. This is caused by the extended or thoracic vertebrae, not by the functional FORCES of the anatomy. These thoracic vertebrae exist in all animals. Muscles attach to these bones, allowing for the suspension of heavy necks and heads. A giraffe's thoracic vertebrae are enormous, allowing functionality to occur with the long neck.

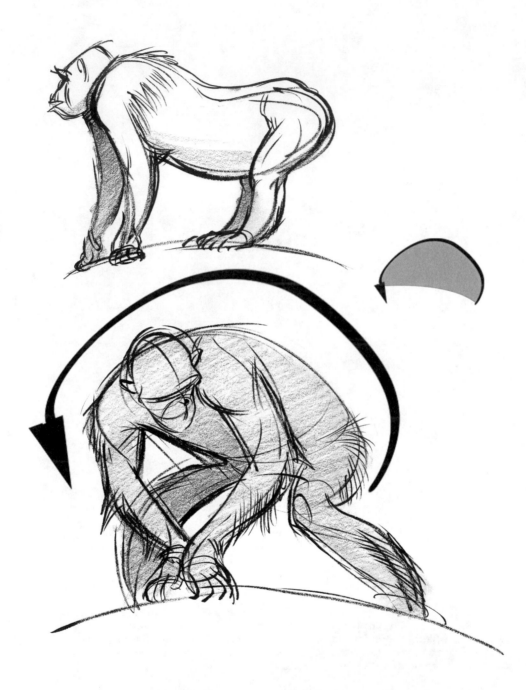

Each of these poses describes a specific type of chimpanzee characteristic. The top image presents a more casual, four-legged standing position, and below is the action-packed stance. Notice the forceful shapes found in the image below to simplify its intentions. I called out the primary **FORCE** shape found in the hip and torso region of the chimp in the bottom pose with this shape on the right. The directional **FORCE** curve is balanced with the structure of the straight line on the bottom.

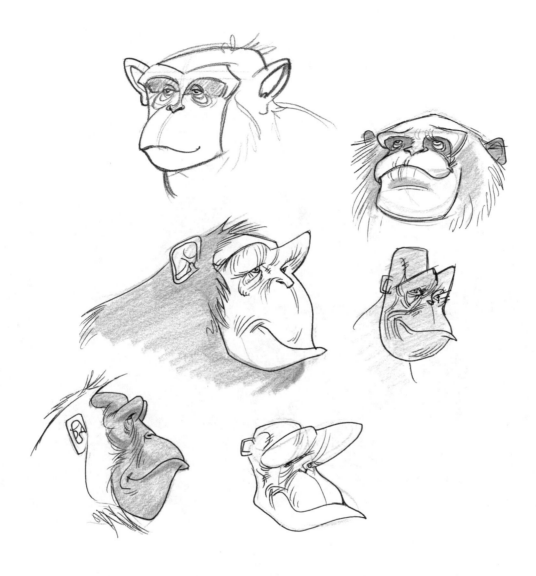

These fun designs exhibit my intentions while analyzing and reacting to the chimpanzees' faces. The designs' ideas range from large brows to droopy lower jaws to overextended lips. You could also think about people that the animals remind you of as a source of inspiration.

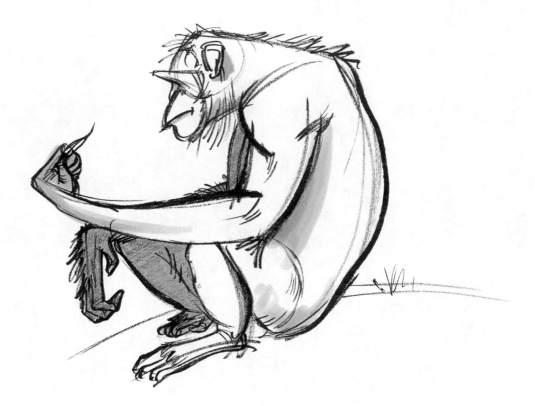

By pushing design or stating our opinions, we can see more clearly the extended arms and the chimp's prominent feet. The neck and head aggressively jut out of the body. Then lastly, but most importantly, there is the story of the chimp contemplating the leaf, exhibiting cognition.

Lemur

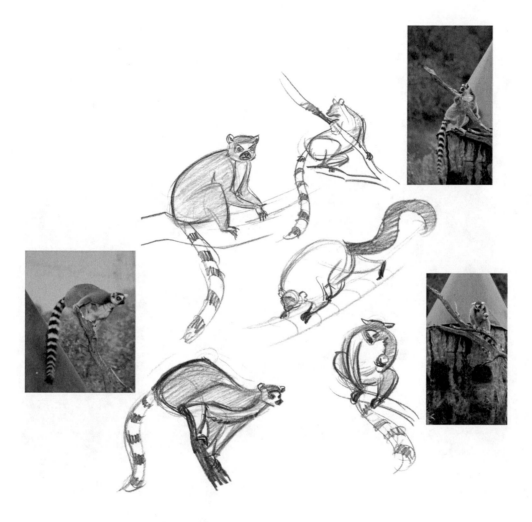

Lemurs are arboreal. They are small and can walk on top of branches, using their long tails for balance. My process for experiencing the lemurs was to define simple, forceful shapes and then fill them with mass by clarifying overlapping moments and the banding on the tail. These lemurs were two-minute studies.

The lemurs mark the end of our journey with the primate family and plantigrades. Now let's move to our FORCE animal shape and see how it interacts with the rest of the animal kingdom. On to the most prevalent and accessible class, digitigrade.

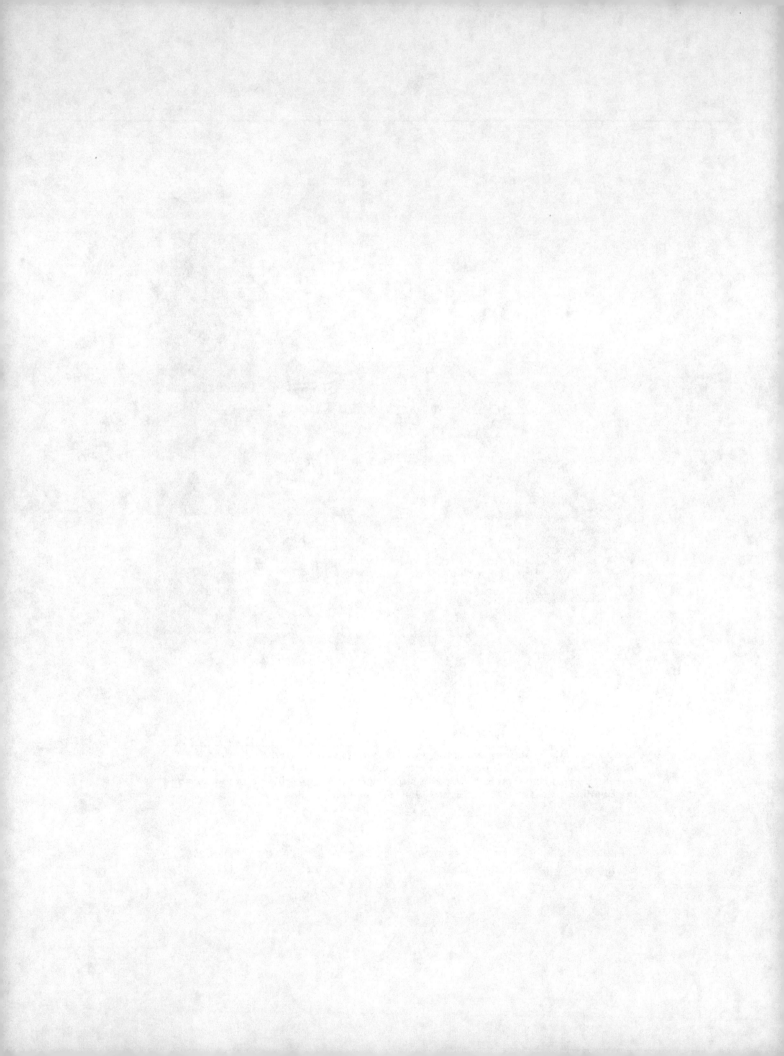

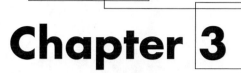

Chapter 3

Digitigrades (Intermediate-Speed Land Animals)

A digitigrade animal is one that stands or walks on its digits, or toes, by definition, although I see it more as the ball of the foot or pad of the hand. Digitigrades include walking birds, cats, dogs, and most other mammals. They are generally quicker and move more quietly than other mammals. Let's start with man's best friend.

DOGS

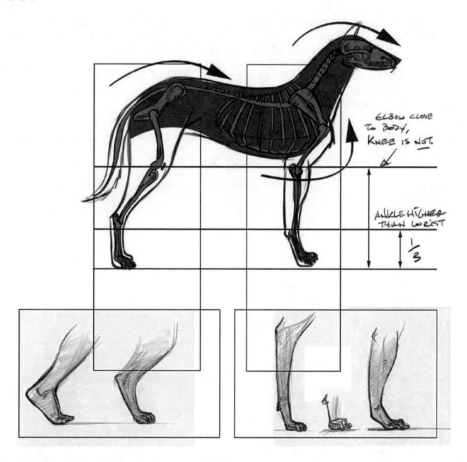

ELBOW CLOSE TO BODY, KNEE IS NOT.

ANKLE HIGHER THAN WRIST

$\frac{1}{3}$

The most common of animals is the digitigrade class due to our household pets, cats and dogs. They are great to study since you can touch them and feel their anatomy, you can observe them more often than other classes, and they are one step removed from human anatomy when it comes to their hands and feet.

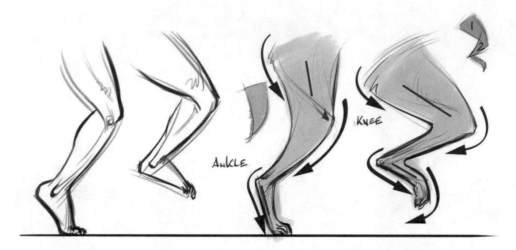

This image shows the **FORCES** of the rear leg up close. In the third drawing from the left, **FORCE** travels down the rear, across to the knee, back to the ankle, and shoots straight down the back or bottom of the foot. It then finishes over the pad and toes of the foot. The image to the far right shows a compressed leg. It moves similarly to a folding chair. The angles found in the upper leg and foot sustain a parallel relationship. The pattern of the rhythm does not change since the rear leg in its more straight stance does **NOT** lock like the front leg.

As an added point of reference, I extracted from the illustrations the triangular forceful shape of the upper leg and how it looks for the stretched and compressed legs.

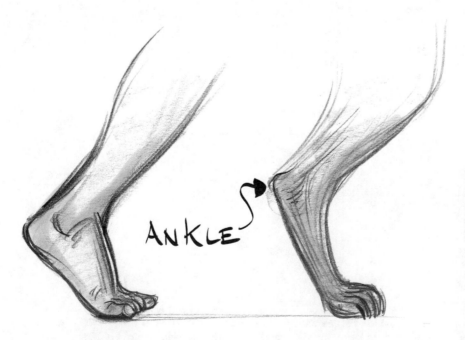

The common mistake artists make when they draw mammals in the digitigrade class is confusing which joint in the rear leg is the ankle. The ankle is the high rear peak in the rear limb of the animal. The digitigrade animal actually walks on the ball of the foot, not unlike a human sprinter. This spring-loaded, bouncy rear-foot architecture allows for a quick burst of speed.

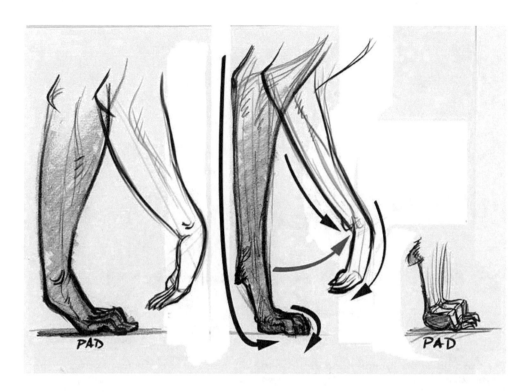

PAD

PAD

This side-by-side comparison of the human hand to the digitigrade forelimb reveals that those in this class walk on what would be the upper pad of the human hand. The small sketch to the far right shows the padding in the area of the skeleton where most of the animal's weight rests.

These diagrams also represent the path of FORCES that occur when the arm of a digitigrade animal is locked back in full support of its weight relative to the arm lifting off the ground. In the drawing of the forelimb locked back, you can see how FORCE drives down the back of the limb to the pad of the foot and then creates a rhythm over the top of the pad and toes. The key element that allows FORCES to operate in this manner is the dog's locked wrist. A human wrist does not lock, and the palm of our hand would press against the ground. The wrist in digitigrades operates like a human knee. This means that the joint has a limited range of motion. When the wrist breaks upward, FORCE creates rhythm earlier than in the locked position by flowing over the top of the wrist and then over the top of the "hand" to the toes.

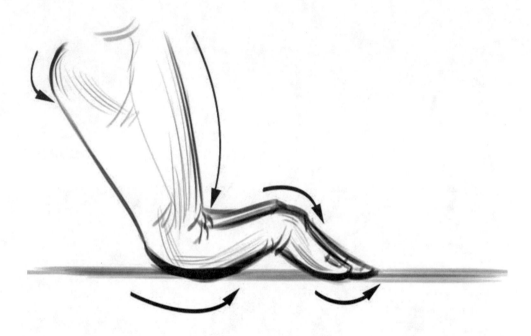

The close-up of the human hand displays the rhythms found in the front paws of the digitigrade animal.

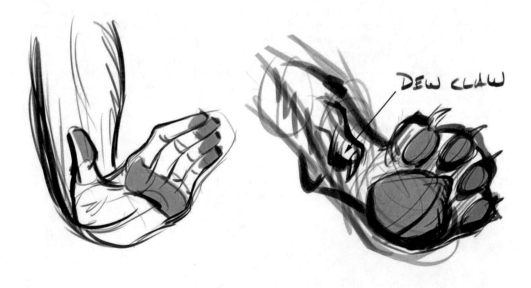

DEW CLAW

The image above brings focus to the comparison in padding found in the human hand to that of a dog. The toned regions clarify how the dog's foot is designed. It walks on the large pad of its foot, which is like the top, large pad of the human hand. Notice how the dewclaw, or thumb, has been pushed up the dog's limb since its function is not as important as a human thumb.

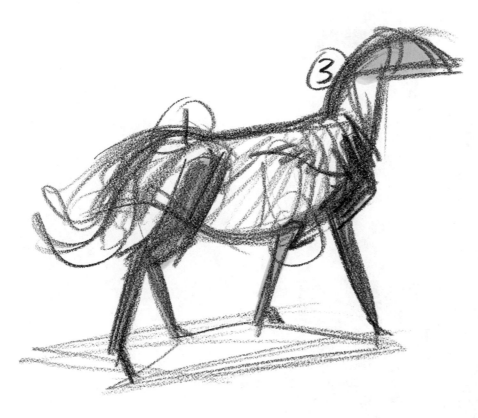

This crude schematic portrays the **FORCES** found in the dog shape. Each **FORCE** is numbered. I want to call your attention to the perspective plane on the ground. Mammals most often have four points that touch the ground, whereas humans have two. Since there are four points, they lend themselves nicely to defining a box, and a box is a great way of defining perspective.

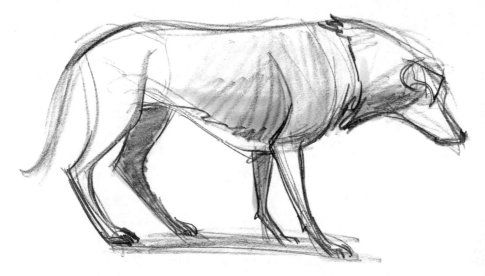

If you do not have access to a zoo, fear not; you don't have to go far to draw animals. Likely, either you or someone you know has a pet. Let's look at our first real dog! Observe the shapes used to create this experience with Belle, the wonderful pet belonging to my friends Sally, Jon, and Madeline. She is a short-haired collie. Notice the **FORCE** body shape overlapped with the fore and rear limb shapes. A large chest and narrow waist give her an athletic silhouette.

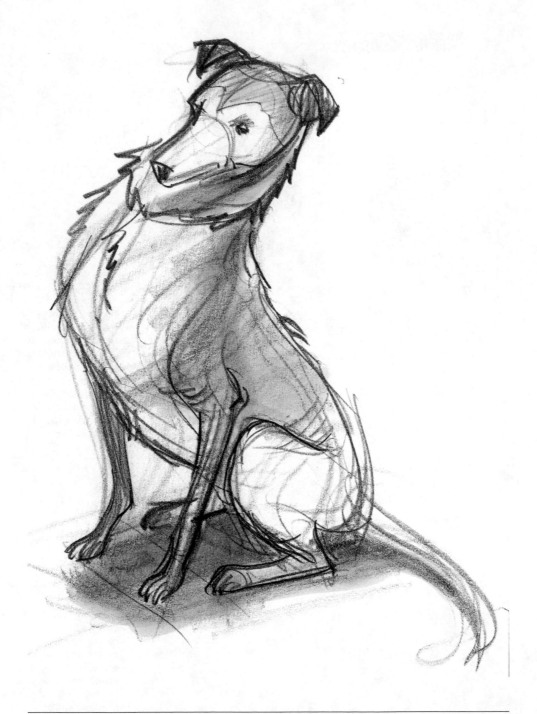

Belle looks on with curiosity at her owners. The foot takes on a human resemblance, since it is flat on the ground. Now you can more clearly imagine the human anatomical comparison. You can see again how I used the perspective plane to define the space she sits in. Notice the sweep beginning at the back of her neck that then led me down into her shoulder and her arm.

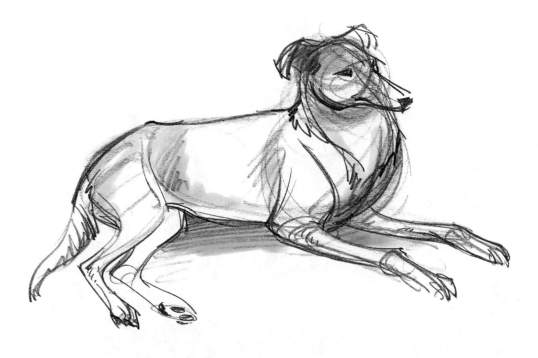

In this drawing of Belle, she is reclined yet looking on at the events around her. She props herself on her elbows and then rotates her hips on their side. You can see how I looped around the joints of her wrists and ankles and described the form of her body with surface lines at the bottom of her abdomen.

During the final proofing stage of this book, my family acquired a long awaited dog that we named Monty, a four month old Black Labrador Retriever mixed with Corgi! Above are a couple of thirty second sketches of his first day at his new home. When addressing these quick ideas I start with the thought, "Monty is _____!" This sentence focuses my thoughts more quickly on the idea of the pose.

Each of these quick sketches was drawn in under a minute. The two on the left were more for the story of the pose and gesture, while the drawing on the right was building the dog in perspective. You can see the difference in thought and appearance of the drawing. The perspective drawing presents more straights than curves to block out the structure.

These images show three different dog breeds in three distinct types of poses.
The FORCE shape holds up to the different activities. All you need is the shape and an
understanding of a locomotive class's limb anatomy, and you are off to the races.
Each of these drawings was executed in under three minutes.

This designed dog was looking up at a squirrel in a tree with great curiosity. The ideas I went after to design this image were long, thick neck; muscular shoulders; big, floppy ears; and a thin, raised chin.

Fox

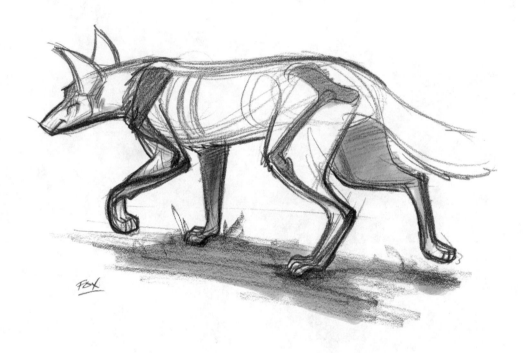

In this image of a fox, I have called out the underlying skeletal anatomy of the front and rear limbs. See the angles that occur through the functions of the legs and how muscular anatomy reacts to these functions.

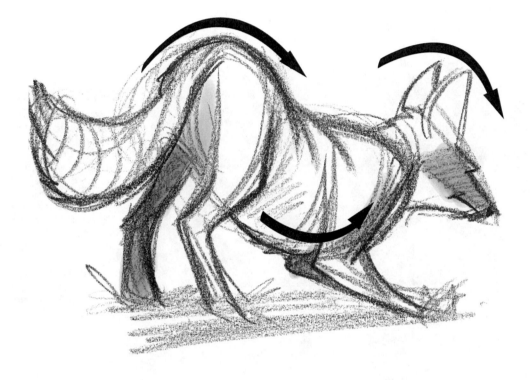

This playful pose of the fox exhibits the FORCE shape with its three main directional FORCES.

Wolf

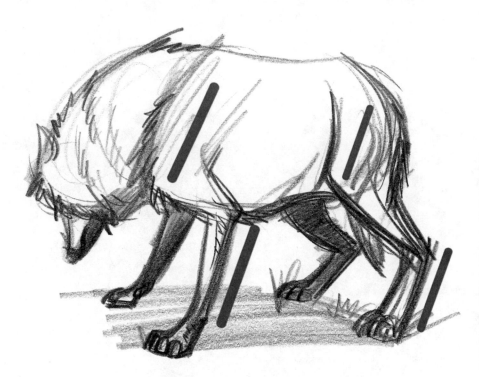

This wolf stands solidly on the grass-covered ground. The difference in length of the back foot and the forelimbs allows it to cover great distance with each stride. The long foot springs its way forward while the arms reach out for distance. Its thick coat protects it from cold winters. See the parallel lines created in the shoulder blade to the forearm and the thigh to the foot. This parallel rule will get you out of tight spots when posing animals from your imagination.

The prairie dog from the plantigrade chapter returns. This time he entertains the wolf. The wolf's three-leg stance allows the wolf to raise its front, right paw, used to investigate its newfound toy.

Hyena

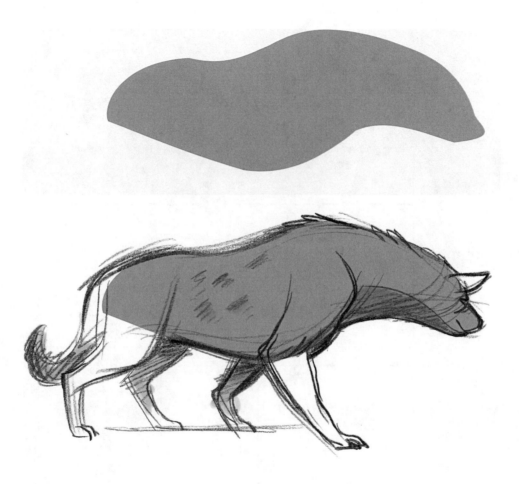

This drawing of a hyena presents a more thick and robust **FORCE** animal shape. The large chest area and narrow lower body create a body design similar to that of a bodybuilder with a thick neck. You can see how most of the animal's power resides in the top half of its body.

CATS

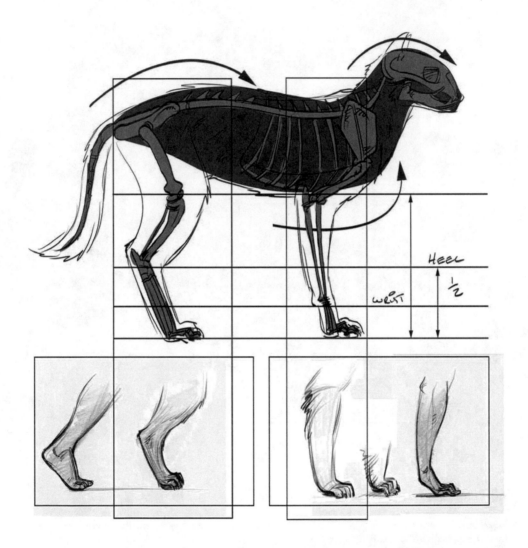

This image shows the common domestic cat. Notice that its rhythms are similar to the dog. Three major **FORCES** create the design of the animal shape. Long back feet allow for its springiness. The cat is agile and light. Quick bursts of speed allow for it to catch prey...or chase a ball of yarn.

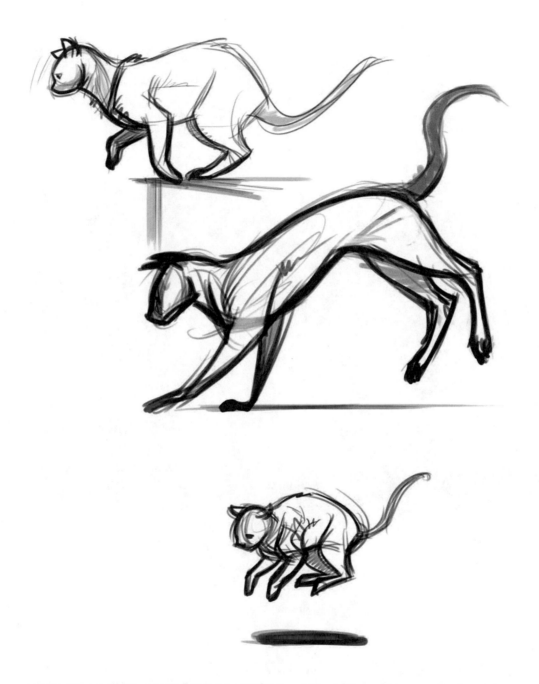

Once you get a sense of the comparative anatomy and the FORCE animal shape, it is easier to draw the most energetic of poses, as you can see on this page.

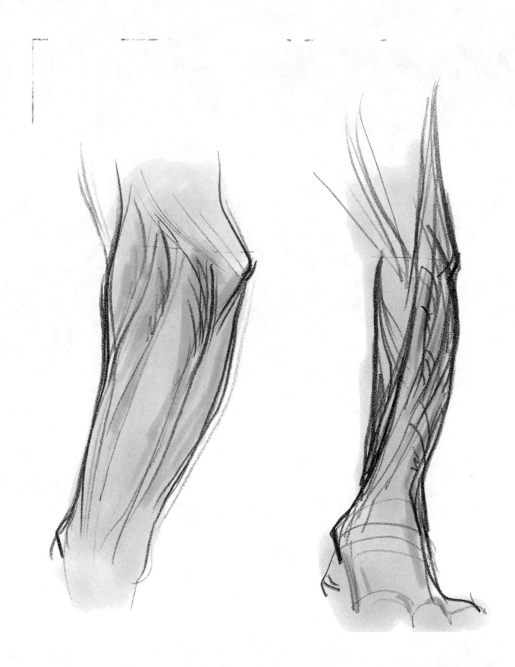

Look at the resemblance between the human forearm and the animal's forearm in this image. Notice the rhythm similarity based on FORCE in the forelimb. It strikes me as peculiar just how similar the anatomy of all animals is.

Lion

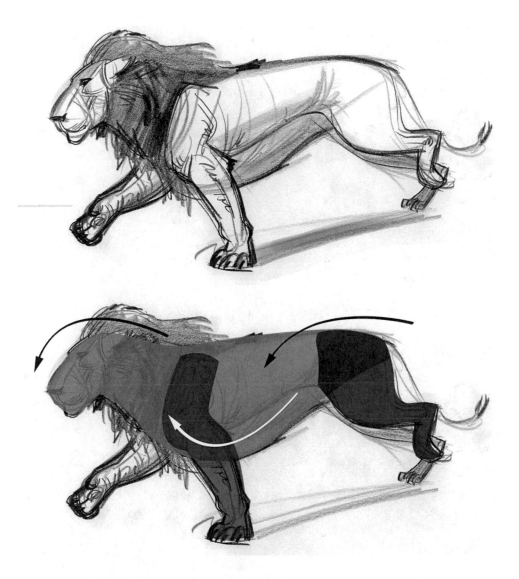

The two limbs on opposite sides of the lion's body carry its weight in the midst of this stride. Look at the drag on the raised back leg caused by the curve of the foot created by its forward momentum.

In the below image, I have pulled forth the **FORCE** shape and that of the fore and rear leg of the close side of the lion. These shapes reveal the function behind the top drawing. My main thought during the experience of this drawing was the momentum of the lion's rear pushing forward into the front leg's shoulder. **FORCE** then drove up into the neck and the face.

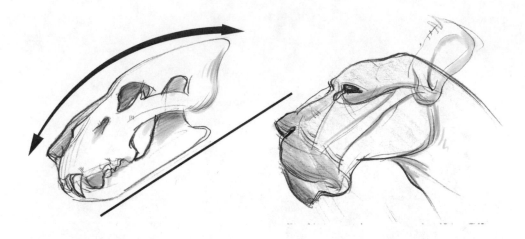

Studies of the lion's skull reveal its carnivore diet. The large curve at the top surface of the head against the straight of the bottom represents the amount of **FORCE** exerted downward to chew through tough flesh instead of soft, leafy vegetables.

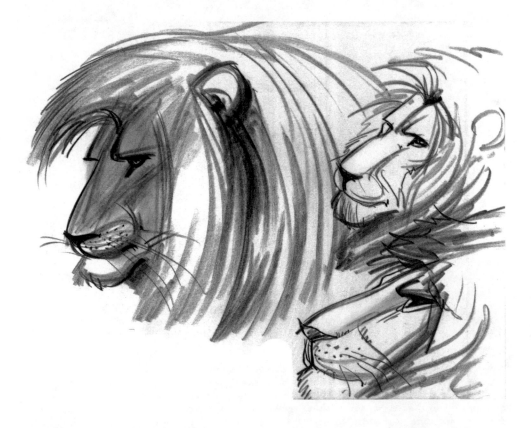

These drawings show the majesty of the male lion's face. The strong brow, thick nose, and protruding chin all add prestige to the lion.

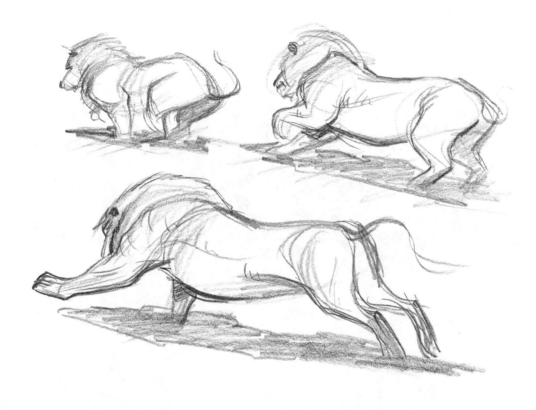

These awesome reference images came from a documentary I caught on television. This male lion chased down an antelope in a swampy, muddy terrain. This allowed me to more clearly observe the architecture of anatomy due to his high levels of exertion as he ran down his prey. The lion's body squashes and stretches to allow for the reach it needs to move at high speeds.

You can appreciate the drag of the front left leg in the second image as it then stretches out in preparation for the next stride.

Throughout these moments of functional contrast, the **FORCE** shape still sustains itself.

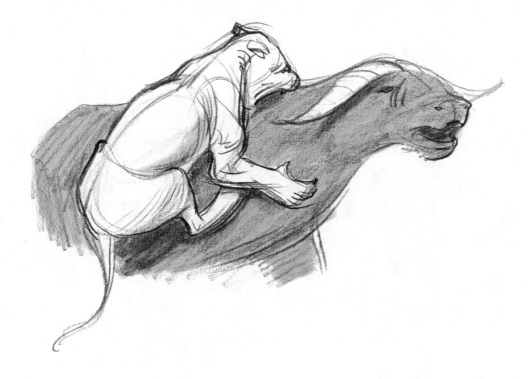

The female lion takes down a water buffalo. The convex arc of its body along with the strong jaw and sharp claws retain its attachment to the buffalo. An interesting fact to observe is the lion's level of rotation in the wrist, allowing it to grab the prey. Only the plantigrade and digitigrade classes are capable of this rotation. The unguligrade wrist is locked and has barely any rotation due to the fact it is not carnivorous.

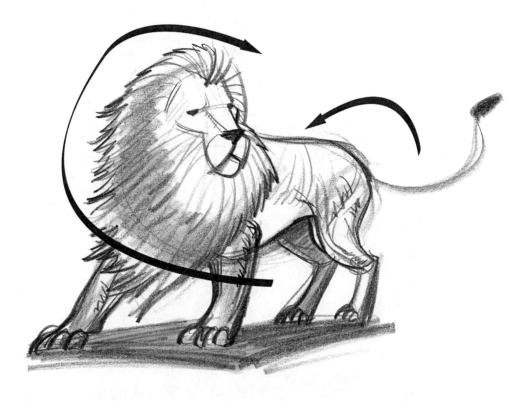

The first two **FORCES** that I addressed in this lion's pose were the two directional **FORCES** presented up above. I started with the **FORCE** in the hip area and that led me across the body, down to the chest, and then around into the neck and head. You can also see the clear **FORCE** body shape that drives energy from the hips up to the head. I added the perspective plane to ground the feet and accompanied that with **FORCE** surface lines to assist with the structure.

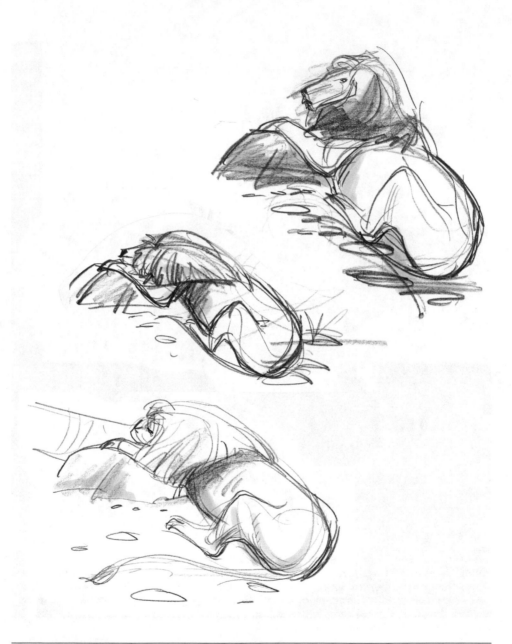

These three drawings depict a reclining lion at the San Francisco Zoo. In the top image, observe the three surface lines on the back, left leg that give us form and **FORCE**. In the second image, I brought with me what I learned about the lion's **FORCES** from the first experience and added thoughts about the mane design. The last image, and my third experience, was a culmination of the first two. More anatomy is present, all with **FORCE** and design. There is a more efficient process here due to my history with this lion in this pose.

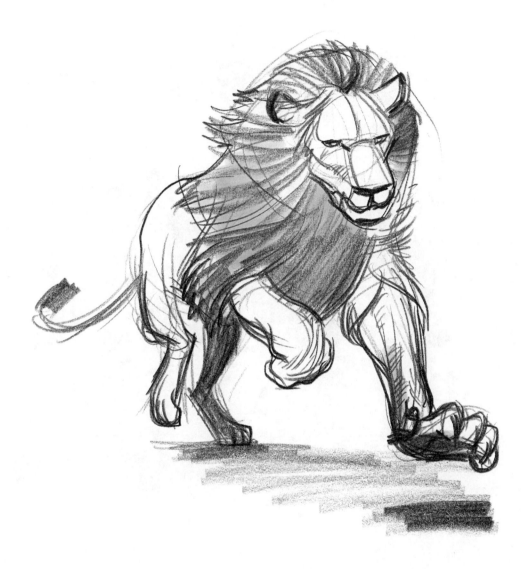

The **FORCE** pushing down in the lion's front left paw, coupled with the curling inward gesture of the right, accentuates the forward propulsion of the lion. This moment in time occurs just before the transfer of balance from the back of the lion to the front and to its left side. This pattern is slightly different from the walk, since both back legs will leave the ground and replace both of the front legs' positions.

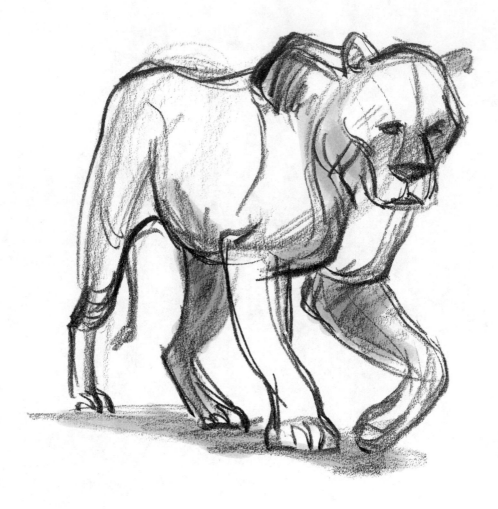

This lioness makes her way across the savannah after losing her lunch. I focused on the weighted feel of her walk. This can be seen in the amount of pressure placed on the line that describes the shoulder of the supporting leg. Again, you can see the shoulder blade protrude past the forceful shape silhouette of the lioness—another clue to how her body operates.

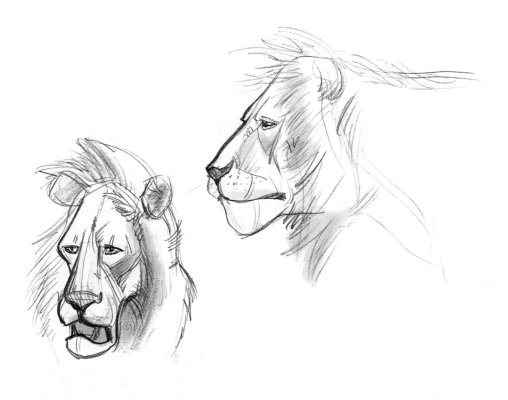

Studies similar to the drawing on the right allow for creating designs as shown in the example on the left. The lion's face is thinned out here and stretched vertically to more clearly express its specific nuances. Observe the plane changes on the face and their ability to define structures.

Cheetah

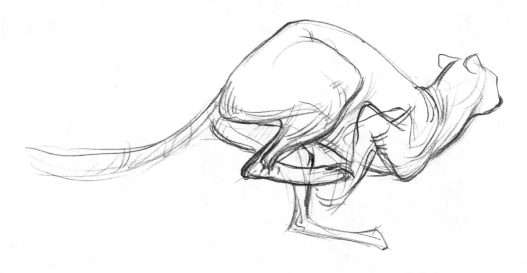

Let's move through the process of drawing this cheetah by visualizing its forceful shapes.

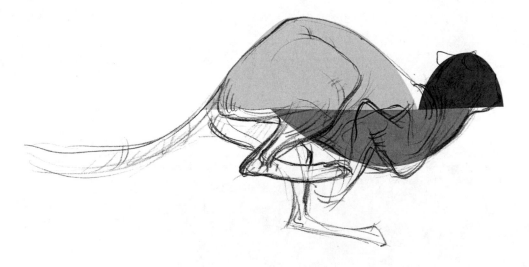

This image presents the FORCE shape divided into its three directional FORCES. Observe how FORCES flip from the hip and back, down to the chest, and then up to the neck and head. These moments combined are the FORCE shape.

After designing the body of the cheetah, I overlaid the legs. The shapes of the legs are also created from forceful shape rules. See how FORCE runs from either the shoulder or hips and rhythmically flows down the limbs to the paws.

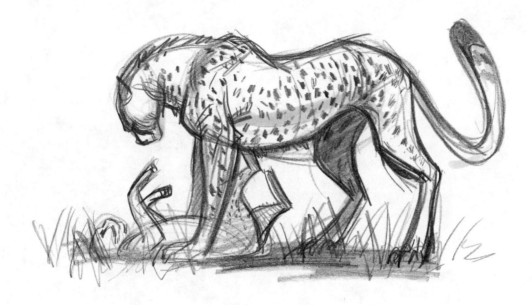

Now that you have seen how the cheetah breaks down into its basic elements while sprinting, let's look at a more peaceful story moment between a mother and one of her cubs. FORCE, form, and shape come together to define this image. Some other minor points to draw attention to are the strong bent angle found at the top of the hip region, the clarity of the shoulders, and the lean, long feet that allow for the spring in her step.

Cheetahs are the earth's fastest land animal, capable of speeds over seventy miles an hour! Think about driving on the freeway at that speed with your windows open to get a sense of what this type of speed means.

At these high speeds, the cheetahs' momentum helps keep their body upright, so more energy can be used in the forward movement. The long tail of the cheetah is there to counterbalance the steering of the cheetah's front legs, allowing it to steer through aggressive turns.

The main directional FORCE in this image drives its way up to the top of the shoulders as the cheetah leans against its right arm, hand hanging over the rock. Follow the rhythm of FORCE as it sweeps its way rhythmically from the shoulder down to the paw. I truly enjoyed the experience of drawing the round head and wide, flat nose.

Ocelot

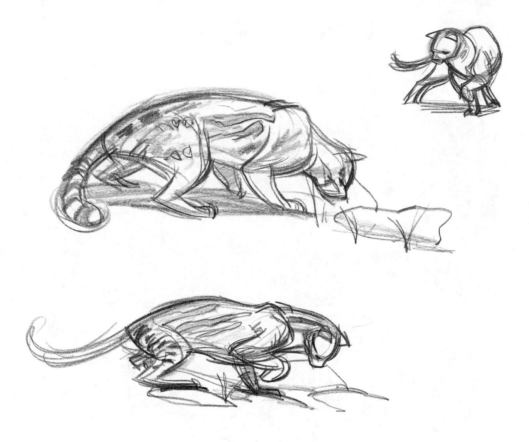

These quick studies of an ocelot investigating a snake's home present interesting poses. Look at the use of the tail for balance. Simple shapes have been designed to quickly create the poses. Look for the **FORCE** body shape and then the overlapping appendage shapes.

Leopard

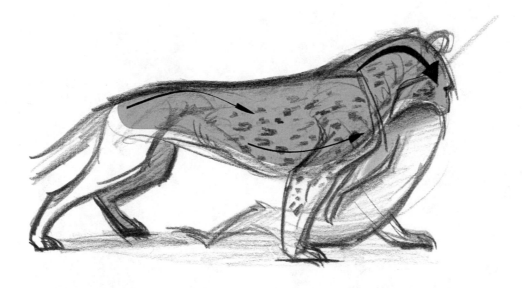

The ever graceful and powerful leopard carries a dead baboon away to the trees. The great amount of FORCE in the leopard's upper neck is due to the weight it carries in the dead baboon. The prior rhythms allow for this balance in power. The front legs drive up and forward over the ribcage, propelling the leopard forward, up into the trees where it will eat its prey.

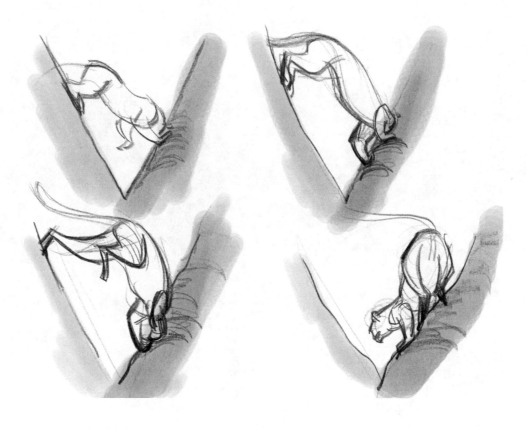

This leopard makes its way down the V-shaped tree. The rear of the leopard is propelled from the left side to the right, over the center of balance found lower in the ribcage. The back legs compress and stretch to execute this maneuver. The leopard's strong upper body allows for the cat's acrobatic maneuver.

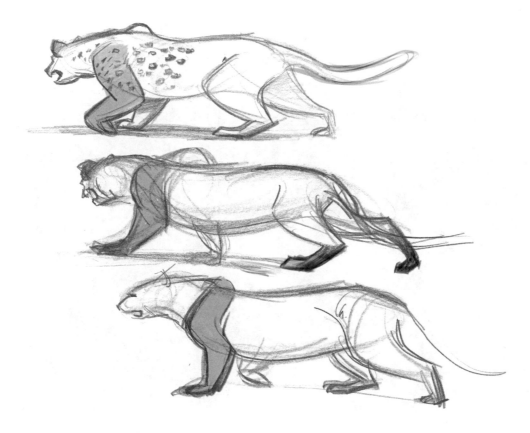

These quick studies show a leopard during a stalking stride. The weight of the upper body shifts from left to right as it stays crouched through its paces. The front paws barely leave the ground as they move forward in space, bent at the wrist, ready to snap down to support the body once more. The body's **FORCE** shape stays the same as the limbs go though their motions to support the main body and move it forward toward its prey.

Tiger

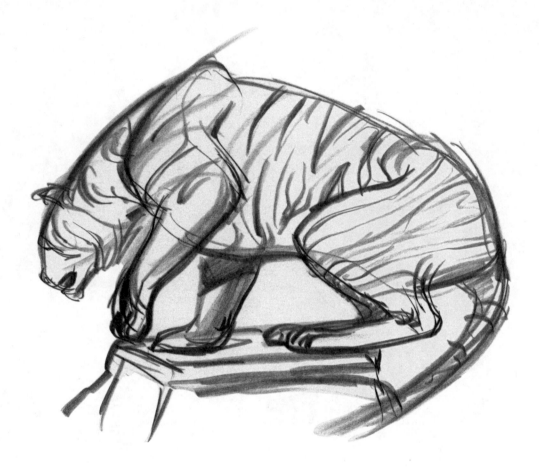

The tiger has the body of a prized fighter, muscular, barrel-chested, and lean. Here, it sits on a rock poised for its next move. It possesses wide thighs and thick forearms. The tiger's shoulders are heavily muscled, and the tail balances the large cat. Observe the parallel limb rule in action here in the front and rear limbs.

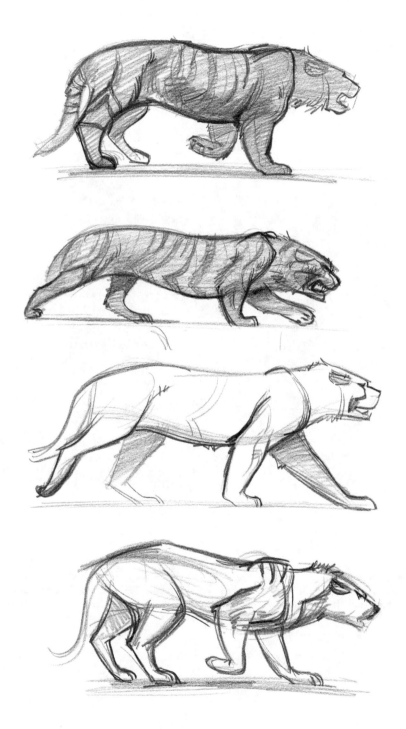

Drawing an animal walking—in this case, a tiger—is a great way to study its anatomy. You will quickly see the sliding shoulder blades, the raise in the hips, and the body shape connecting all of it. These images are not evenly distributed through time and are to be used more as a guide to the transformation of anatomical shapes relative to their function in each moment in time.

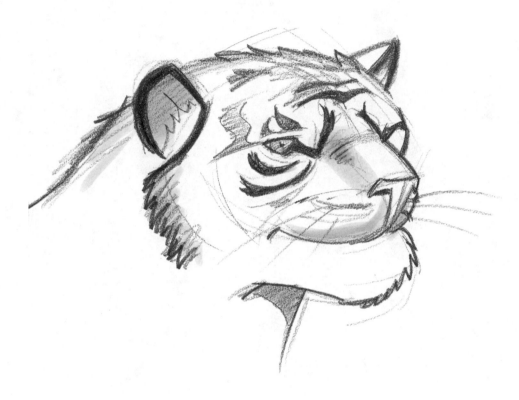

This tiger design presents a thick face created with a wide nose, tall chin, and heavy brow. It is so easy to think "tiger" or "zebra" or "lion," but to see variety and human characteristics in the face of an animal is another task in itself. This tiger looks athletic to me due to the overall shortness and thickness of the features.

ELEPHANTS

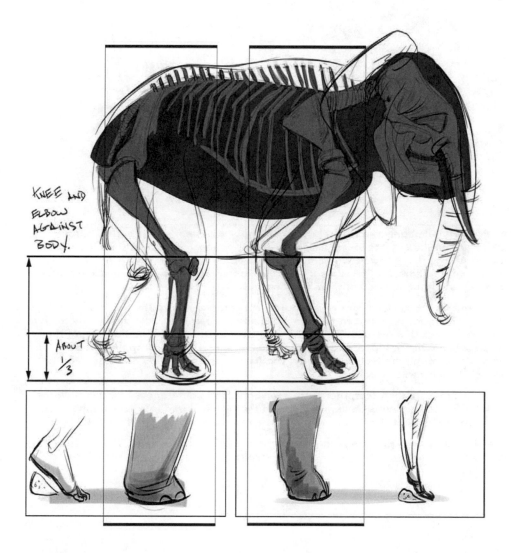

KNEE AND
ELBOW
AGAINST
BODY.

ABOUT
1/3

Surprise, surprise . . . elephants are digitigrade animals—well, almost. They are considered semi-digitigrade. Why are they classified as such? The secret lies in their feet.

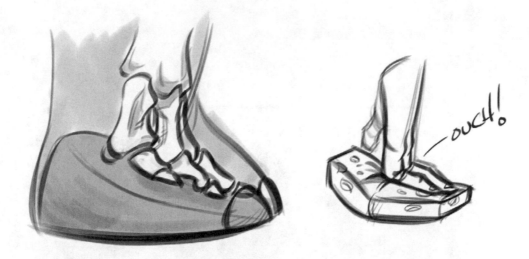

Notice how elephants possess a large, gelatinous pad under their bones, hidden away within the shell of their round feet. They don't rest their weight on the pad of the hand. The first knuckle within the finger is what rests on the pad! This makes them semi-digitigrade. They do not walk flat-footed, or plantigrade, and they are not all the way up on the ball of their hand or foot.

There are basically two types of elephants: African and Asian. The quickest distinguishing factor between the two is the size of their ears. African elephants have enormous ears that are used as a cooling system for the body. The flapping of the ears cools down the blood that flows within them, and then that cooled blood circulates through the rest of the body. The Asian elephants' ears are a quarter the size of the African elephants'.

When it comes to their feet, there also are some subtle differences found in their toe count. African elephants have three toes on the rear feet and four toes on the front feet. Asian elephants have four toes on their rear feet and five on the front.

The elephants' legs are like pillars supporting their massive weight. The joints can lock into a straight position, allowing the elephants to basically rest while they are standing.

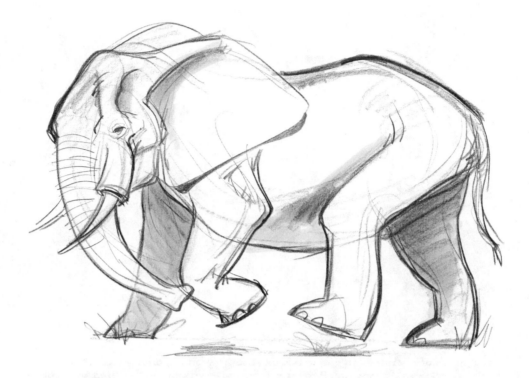

This image of an African elephant (check out the ears) clearly presents similarity to human anatomy in the fore and rear limbs. The rear leg is about to fill the space that the foreleg just resided in.

Due to the elephant's weight, the foot appears to swell when it hits the ground and get smaller when it lifts from the ground. Because there is such an obvious change in the size of the elephant's foot, the elephant is capable of pulling its feet out of deep mud. The weight of the elephant widens the foot when it presses down in the mud, making the hole that was created by the foot larger than the foot as it rises out of the hole, since the foot does not have such a tremendous amount of weight on it anymore.

I spent much of my attention during this experience working on form. All the form fills the clear, profile silhouette. Profiles are the most difficult to fill with form because you are describing the animal in its most narrow state. A three-quarter view would be the simplest. The slightest curvature of line insinuates form, and being aware of those subtleties is key.

With this elephant leaning into its rear, I focused on the back and upward motion of this pose. The close back leg is a great indicator for how far back the leg is moving, presented by the leg's strong, stretched angle. In the bottom right is a diagram of the FORCE shape with accentuated moments to clearly define the directional FORCES provided on the larger drawing.

While walking, the elephants' legs act like pendulums. Their hips and shoulders rise and fall with each step. The far legs are in the process of the rear foot kicking forward the front foot. Elephants swim well but cannot trot, jump, or gallop. They do have two gaits: a walk and a faster gait that is similar to running. An obvious challenge to this drawing was the vantage point. The perspective had to sustain itself throughout the image. The surface lines along the bottom of the belly, head, and ears helped me keep this vantage point in mind as I moved through the pose.

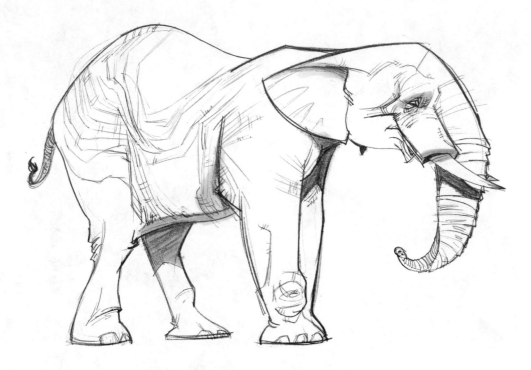

This design, on the other hand, is more flat in its style choice. I made the decision to connect the ear to the head in one line or idea. I thinned out the rear legs and thickened the front. I played with the wrinkling of the trunk and the design of the wrinkles throughout the body.

Both of the back feet have specific, different ideas. The far foot has a sense of stretch on the backside and appears to be suctioned to the floor. The close leg plays with the idea of heavy skin draping itself on top of the foot. The front foot's concept is like a pillar of strength.

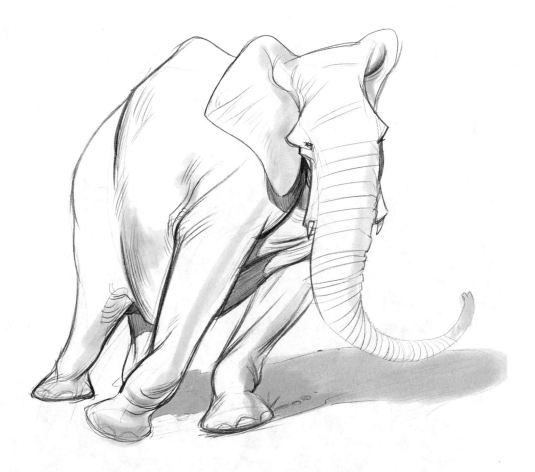

The drifting movement of the elephant toward the right and how it affects its feet was the title or focus in this experience. I love the stretched quality found in the supporting front leg. The skin pulled from the wrist joint up to the elbow and across the chest assists in the sensation or the drift to the right.

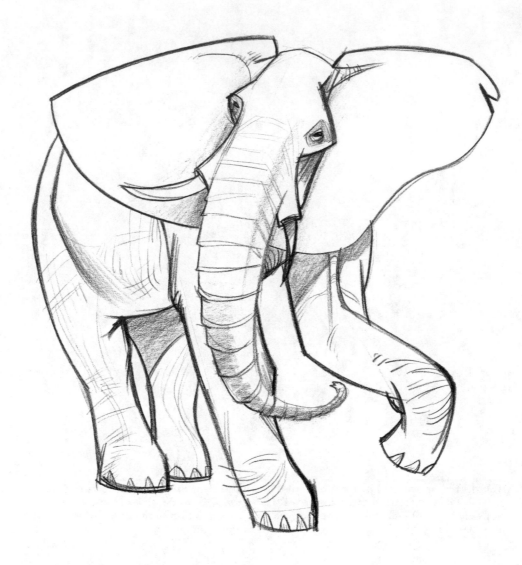

Many different ideas are present in the illustration of this African elephant. One contrast I wanted to define was the stiffness of the one forelimb relative to the taut bend in the wrist of the other. I also wanted to define the box-like structure of the trunk. This was achieved with two different techniques. First, at a line level, the angle change found in the lines that present the trunk wrinkles suggest the box planes of the trunk. Then I added slight tone to emulate shadow, which also defines a change in the planes.

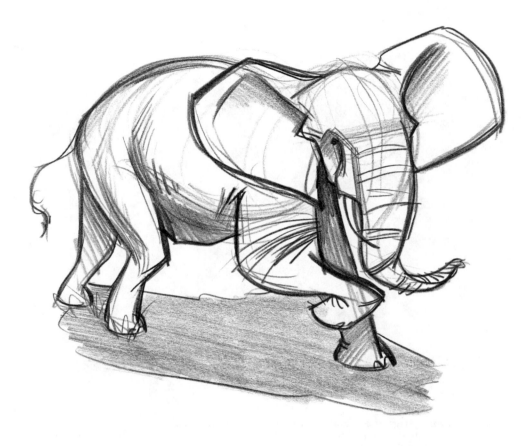

Look at the wide upper arm and pointed, bent elbow in the close arm in this image. The other front foot is wide to present the weight it supports. I thinned down the two back legs and added surface lines for the belly, legs, and trunk to further define structures.

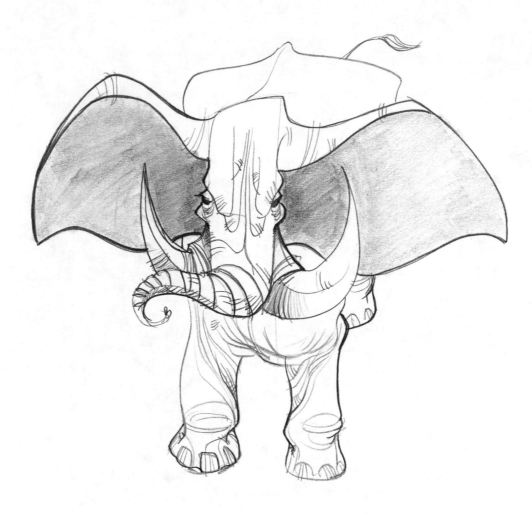

I was inspired by many attributes found in this African elephant. I went after the large ears, which silhouette the thick tusks. Then I made the head a long, vertical rectangle. Lastly, I went after the fluid wrinkles found in the front legs, following their graceful and purposeful patterns.

In this illustration, I took the long vertical rectangle concept further and then designed the ears into more triangular shapes.

BIRDS

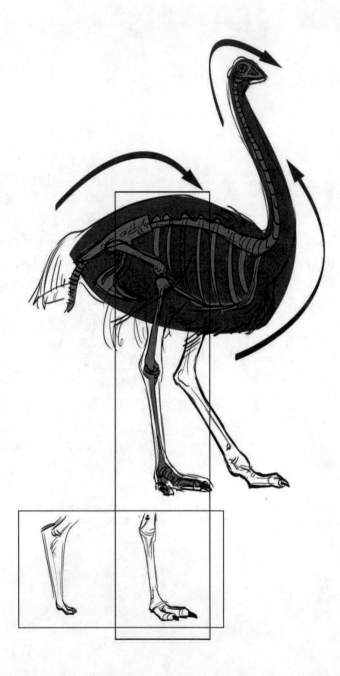

I am ending the digitigrade chapter with a slight departure from all the mammals covered in this book. Let's talk about birds. I felt as though the book would not be complete without the addition of our feathered friends. I specifically have chosen an ostrich as our first candidate. As you probably know, ostriches cannot fly. They can run really fast, though—over forty miles per hour! They are bipedal, which means with two legs. What makes this possible? Their digitigrade anatomy! They do not run on the same padded area as cats or dogs, but they do not run on the tips of their toes either as unguligrades do, as we will examine in the next chapter. Look at how distorted and stretched the **FORCE** shape can be manipulated and still function.

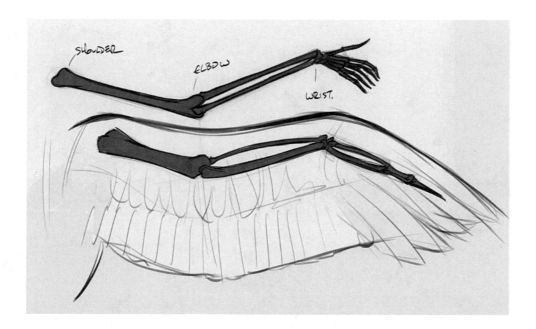

The ostrich illustration gives you a sample of the foot, but I purposely left out the arm or wing. The wing deserves its own illustration, as you witness above. The arm or wing anatomy of a bird is similar to that of a human.

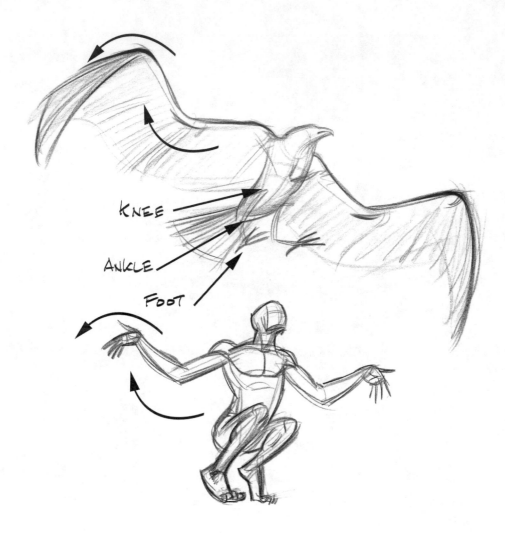

KNEE

ANKLE

FOOT

Here is a full figure human-to-bird comparison. The reason that most artists confuse the anatomy of a bird's leg is that the knee is hidden under the feathers and right near the body. The length of a bird's thigh is generally much shorter than that of a human. What you see protruding from the bird body is the lower leg to the ankle joint.

When it comes to the wing, it follows all the same rhythms as a human arm. The power for the bird's wings comes from the massive chest or pectoral muscles.

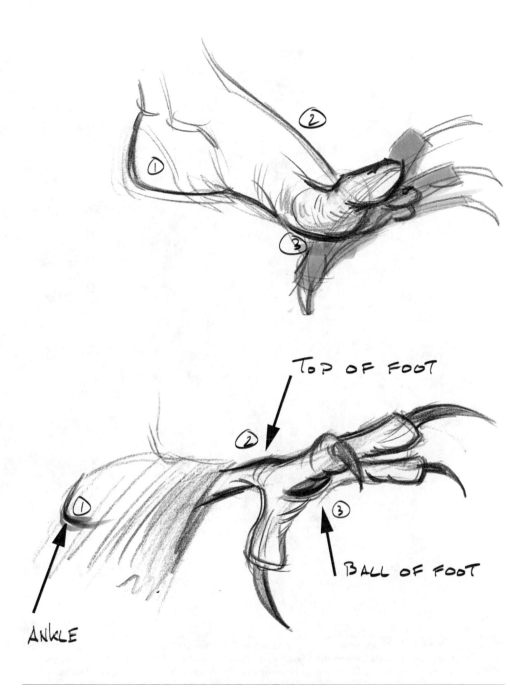

TOP OF FOOT

ANKLE

BALL OF FOOT

In taking a closer look at the foot of a human alongside a bird—an eagle in this case—you can see the ball of the foot is the base of the bird foot, where the toes emanate from. The eagle possesses much longer toes with long toenails or talons for grabbing its prey. When a bird walks, you can see how it walks on the ball of the foot.

OSTRICHE

These quick ostrich illustrations were performed with a purple Prismacolor pencil. The drawings are loose interpretations that investigate form and shape within the reality of the ostrich's anatomy. Give yourself room to think and find forms and shapes.

This eagle soars through the air effortlessly, legs relaxed in a rear position. The eagle's strong chest helps pump its wings up and down. The bald eagle can glide to speeds over forty miles per hour! It can dive at speeds near one hundred miles an hour. That is fast!

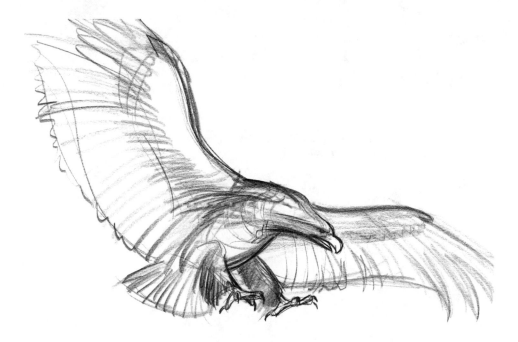

Here is another eagle diving in on its prey. The talons are set forth, prepared to grab the prey.

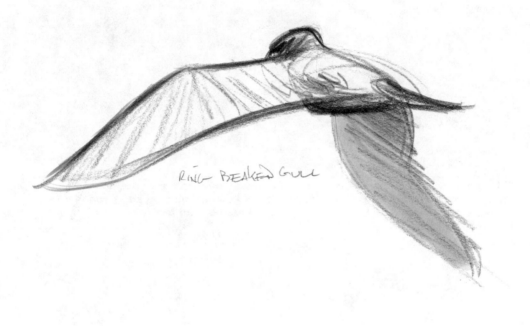

RING BEAKED GULL

This ring-billed gull's wings, beautifully designed, cut through the air effortlessly. Forceful shapes design the wings.

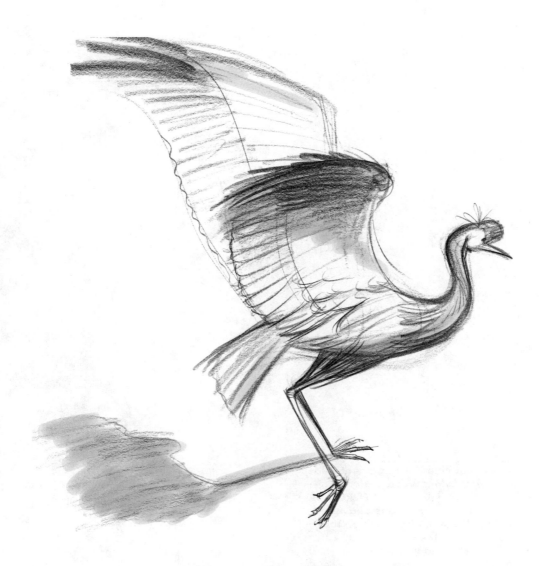

The King crane clearly presents the concept of the hidden knee and the prominence of the ankle. If you can be aware of the bend as the ankle, you will understand the anatomy of the bird's foot. Bird legs are one of the furthest departures from human anatomy. If you can make this jump, then creating all of the mammals in this book should be a walk in the park.

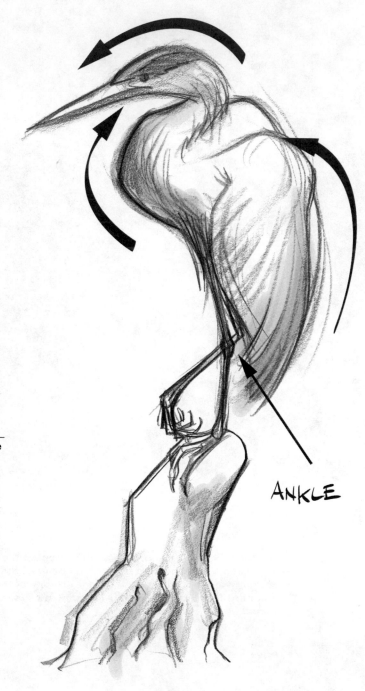

ANKLE

This Great Blue Heron sits waterside on a protruding wooden stump. I extracted the three main FORCES of the FORCE animal shape and called out the location of the ankle. Don't be fooled by the lack of the knee, which is hidden up against the body.

With this great bird, I conclude the digitigrade locomotive class, the most accessible and prominent in the world of animals. On to the last class, the unguligrade.

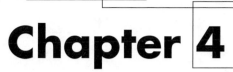

Chapter 4
Unguligrades (Fast Land Animals)

ODD-TOED UNGULATES

Examples of odd-toed ungulates are horses, tapirs, and rhinoceroses. They are browsing and grazing mammals. The middle toe on each hoof is also usually larger than its neighbors.

Larger ungulates typically have tendon-lock systems that allow them to lock their legs to be able to save energy. This locking mechanism affects how we think about the functional FORCES of the front legs, as I will cover in more depth in the following pages.

HORSES

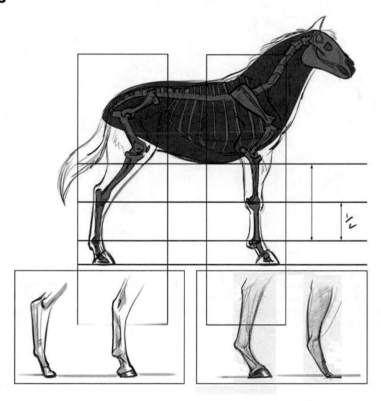

By far, ungulates are the most challenging locomotive class of the three to draw due to the fact that they are the most different from human beings. There is much to cover, so let's get started.

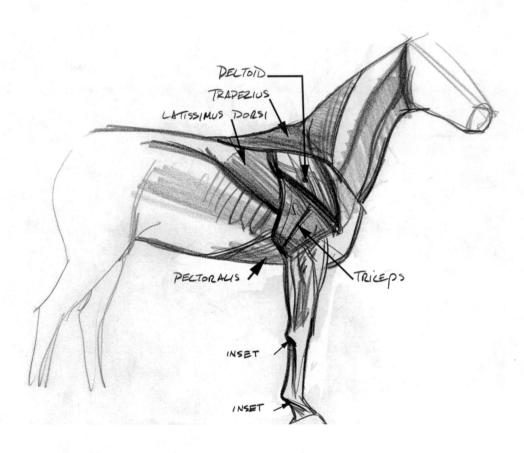

Looking at the anatomy of the shoulder and arm region of the horse, you can see just how similar they are to us. The bicep is the most drastic anatomical change, hidden on the far side of the triceps and almost unseen. The size of the deltoid and triceps informs us of how much work these muscles perform.

Rear Leg

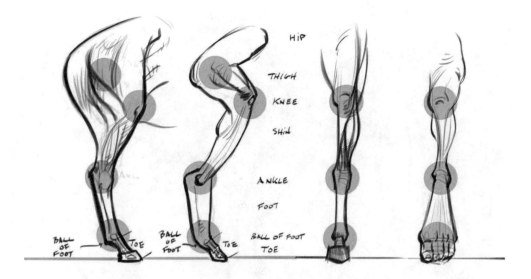

I know this illustration looks bizarre, but this is how human anatomy needs to be manipulated to truly compare to the anatomy of a horse. Let's start with the rear leg on the far left of the illustration. The horse's "foot" and "toe" are much longer than that of a human. The length of the horse's lower leg or foot region allows for a much longer stride than a human. Running or walking on the toe of the foot adds shock absorption and springiness to the run. The horse possesses a wide thigh, or quadriceps, from the side view. This powerful engine helps compress and extend the legs for running and jumping.

The two images on the right provide a comparison of the front view of the back leg. The thigh and calf regions resemble each other closely. It is when we get down to the "foot" the discrepancy is much greater. Keep in mind these comparisons to help you understand how the horse rear leg works.

Foot and Ankle Joints

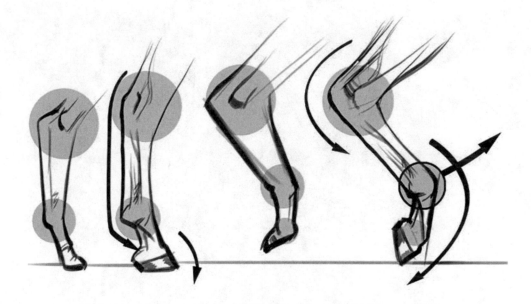

In a close-up of the ankle and knuckle joint, you can see how the bottom section of the horse's leg is like the principal part of the human foot. The human toe is elongated to match the horse's proportion. As the horse lifts its rear leg, the ankle joint raises the foot upward and the toe bends downward. The gray circles bring focus to the major joints and are used as guideposts for the proportions.

Front Leg

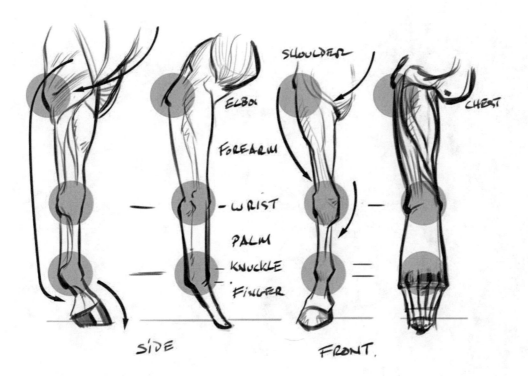

The image above compares the horse's front limb to a human arm. I manipulated the human anatomy proportions to match that of the horse's once more. These changes led to some interesting images. The two drawings on the left show a profile view, and the two on the right exhibit the front view. Notice how similar the forearm region is in the comparison.

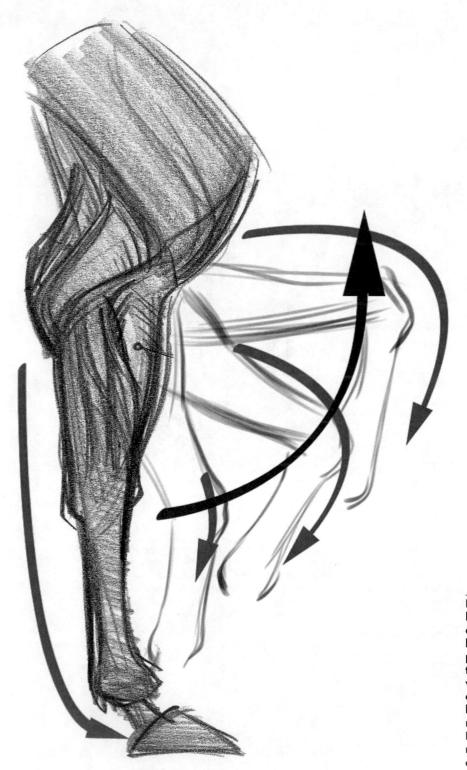

In ungulates, the wrist joint sits in a locked position when it is vertical and **CANNOT** move any further back under the animal. This locked position in ungulates is theorized to transpire to allow the animal rest while standing up due to its size and weight. **FORCE** rides down the back of the foreleg. When the wrist moves forward and snaps upward, **FORCE** adjusts and moves from the rear of the foreleg to the wrist, creating a rhythm.

Front Leg Bent

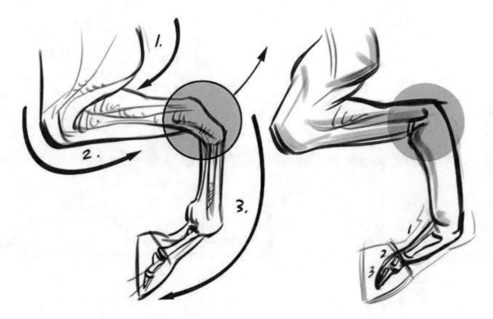

Look at how strange the human palm appears in this profile. You can see how the joints bend in the forelimb. It is the horse's wrist, the joint within the gray circle that presents the dramatic bend. Once the leg bends, FORCE from the elbow, directional FORCE number two, moves across the anatomy to the wrist, creating a rhythm into directional FORCE number three, which did not exist before due to the lack of downward stress.

Knuckle and First Finger Joint

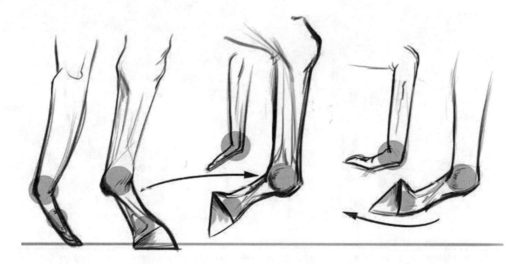

This illustration is broken down into three groups of two. Each is a comparison of the human hand to that of the horse. The gray circles highlight the knuckle and the first finger joint. The close-up of the two joints also presents how much of the stress created by the weight of the horse comes down onto the knuckle joint. In the first image of the horse's anatomy on the left, look at the steep angle FORCE travels through to move from the knuckle joint to the hoof. These knuckle joints break forward, allowing the horse to sweep the toe joint backward and up, which allows for a graceful stride.

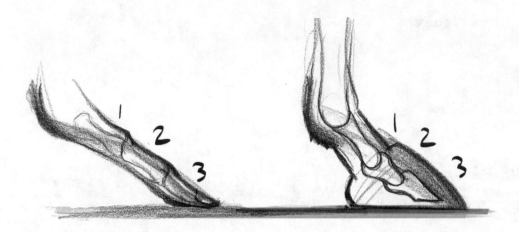

Looking at some of the finer details of the anatomy, you can see that the three digits in the human finger correspond to those in the hoof region of the horse. The main knuckles in the human hand represent the obvious angle change in the horse's lower front leg.

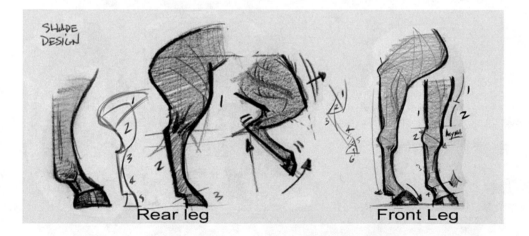

SHAPE DESIGN

Rear leg

Front Leg

In these samples, the front and rear legs of the horse were designed relative to their FORCES. The repetitive triangular shape that is formed from straight to curve design moves its way through the anatomy from one FORCE to another, creating rhythm with shape. In the center of the image, the horse's rear leg is contracted. This morphs the shapes. On the far right is an example of the line separated into its two moments: the concave and then convex curve.

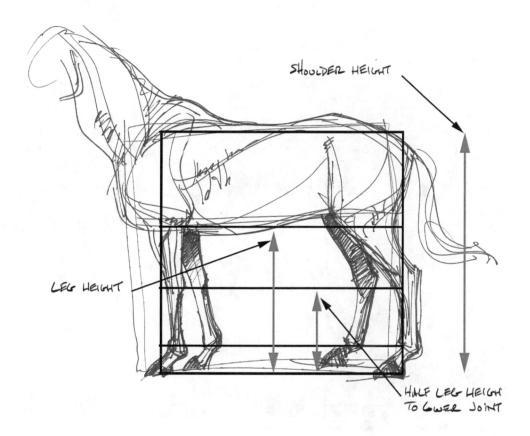

SHOULDER HEIGHT

LEG HEIGHT

HALF LEG HEIGH TO LOWER JOINT

I am not one to do much measuring, as most of you know, but with horses, it is good to have some general sense of proportions until you learn to know what looks right. Every animal drawing book discusses the idea of the square shape presented in this illustration. I think it is a good starting point. The lower joints are called out because the box concept seems to work best from this joint, not the ground level. The next important measurement is the bottom of the horse's ribcage. From the horse's ribcage to lowest joint in the legs, the halfway mark lands the location of the wrist and ankle joints.

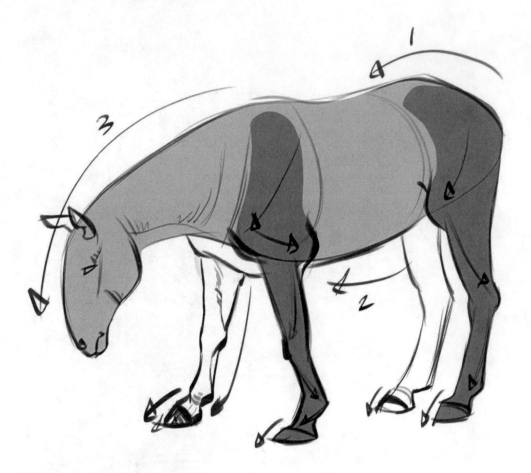

This illustration shows a horse grazing, an everyday task. Look at all the physics involved. Gravity constantly pulls downward, and due to this inevitable truth, the horse anatomy is adjusted. The light gray shape represents the FORCE animal shape. The more dark gray shapes call forth the front and rear limbs. See how the design of the shape indicates FORCE and also form. For instance, the thigh and hip region wrap around the form of the body. The dark gray shape is truly flat, but our minds make it spatial.

Another note to make regarding this illustration is the different rhythms in the two front legs. The far leg stands straight for support, and therefore FORCE drives down the back of the leg. The close leg is slightly bent at the wrist, and the bend causes a rhythm to occur earlier because of this.

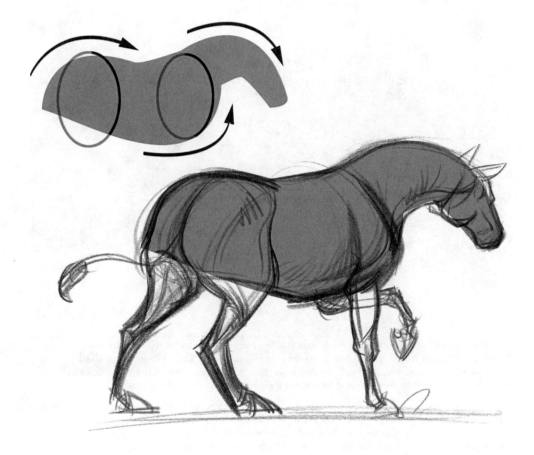

I used this horse drawing as a reminder of the animal **FORCE** shape. The top-left diagram describes the three main **FORCES** along with two ellipses that allude to the perspective the horse resides in.

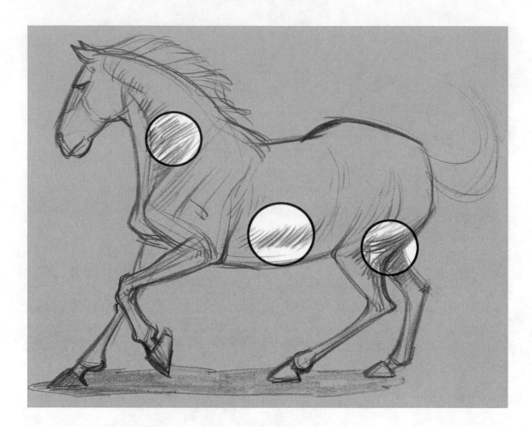

During the experience of drawing this horse, I focused much time on the forms. The three circles highlight areas with line defining form. Each area is handled with a different level of granularity. The center section is the least specific; the neck, or left, circle has moderate detail; and the leg, or right, circle is more informative.

The center circle surface lines are almost scribbled in to describe the form of the belly. The neck is sculpted with line, but the lines do not focus on FORCE, but form alone. The surface lines in the leg circle display form and FORCE! The lines adhere to the forms in the leg in the direction of the FORCE of the muscles found there.

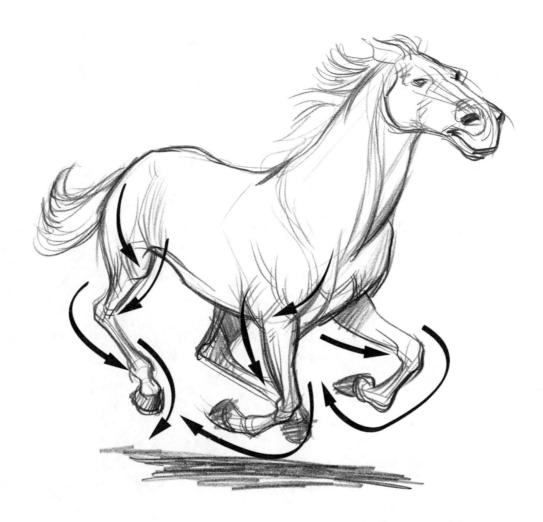

The huge nostrils on the horse feed it oxygen, thus allowing it to run the beautiful machine that it is. The enormous chest cavity pushes this oxygen into the bloodstream, allowing for long-term, high-speed running. All the amazing directional and applied FORCES create ever-changing rhythms while the horse runs.

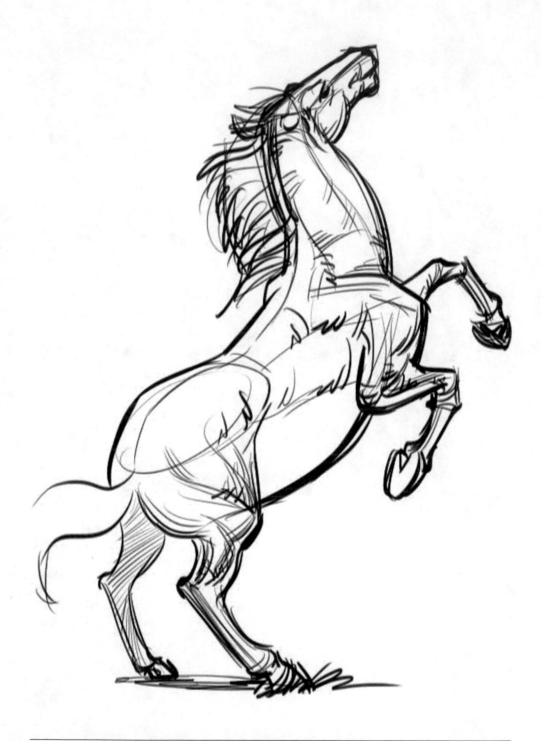

Let's use this drawing as an example of the topics we discussed in the previous two. Look at the FORCE animal shape. This is the glue for the design of the horse. You can see a great variety of surface lines to describe the different forms or muscles of the horse. The limbs all function with different rhythms.

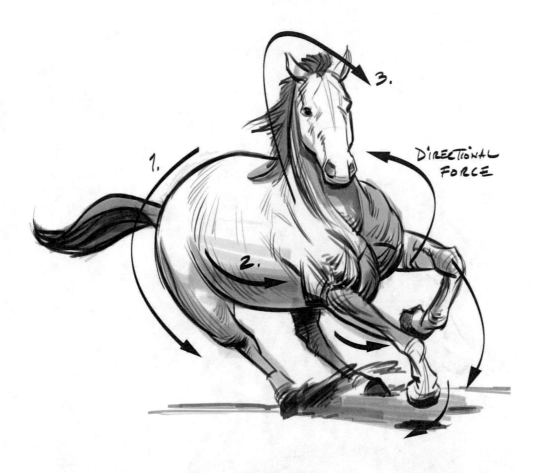

The book's cover image exudes power and speed. Numerous directional FORCES work together creating seamless rhythm. Starting at number one, we follow FORCE'S path to number two, which is part of the area labeled "directional FORCE." This FORCE changes direction and flips to number three, where we screech through a hairpin curve at the top of the head and out the horse's face.

An intimate walk around the drawing presents an immense number of forceful form lines that define the strain and operation of the horse's musculature.

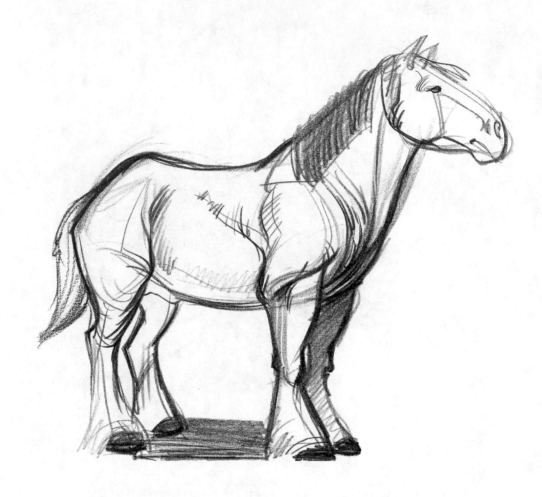

This Clydesdale stands firm with great presence. The shoulder and thigh regions are heavily muscled to support the animal's weight. Clydesdales can weigh close to two thousand pounds (one ton). Due to their docile demeanor and great strength, this breed of horse was most commonly used by farmers to plow and pull heavy loads. Try to see the FORCE animal shape buried within the anatomy as it moves its way over the structure of the legs.

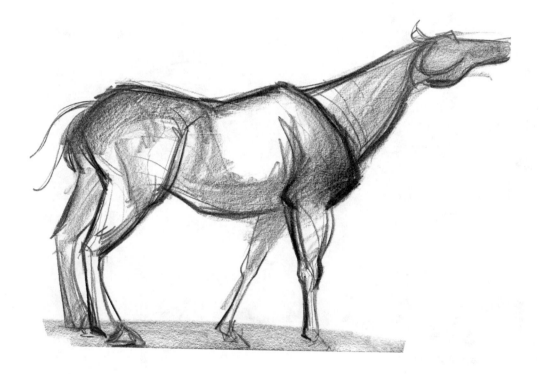

This more angular image of the horse highlights the structures of the hips and the shoulder blades. The more soft, rhythmic neck sweeps out from between the blades, suspending the rotated head in a graceful twist. Look at the clear straight to curve forceful shape that defines the neck. The last curve of the FORCE animal shape would be found beyond the straight of the top of the neck at the top of the head.

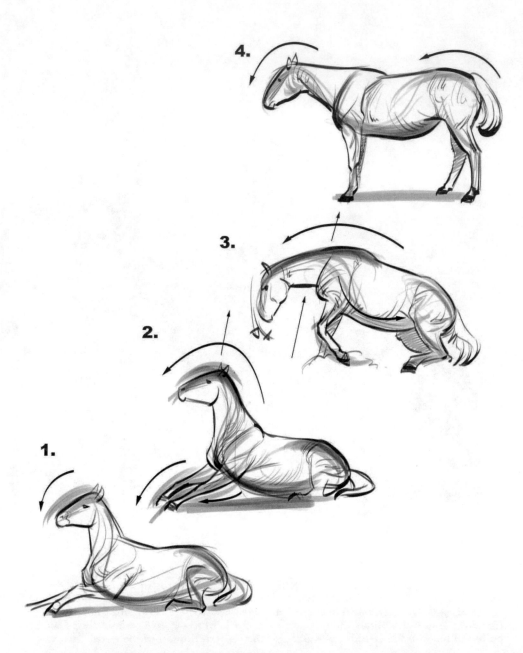

These drawings show a horse getting up from a reclined position. In image one, the horse pushes its head down to anticipate the quick, large, upward thrust that immediately follows, seen in image two. This moment allows the horse to jut its front legs underneath the weight of its upper body. In drawing three, the horse's weight hangs from the shoulders down through the belly into the hip area, and the far front leg is locked under that weight. Since the front is raised, the weight of the rear has somewhere to move, and the horse pulls its rear legs under the body to raise its back end. In image four, the horse is standing.

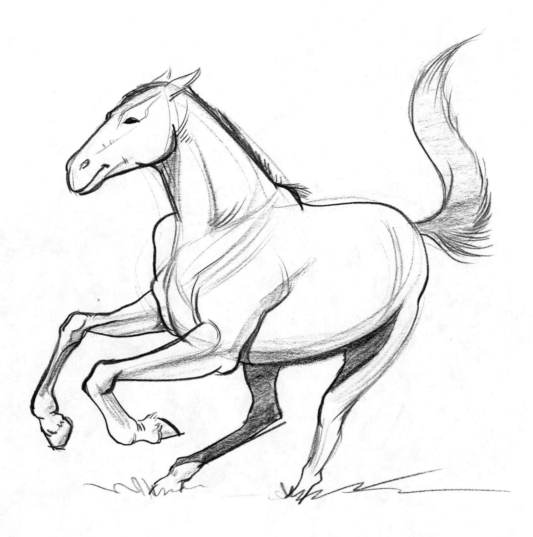

I designed this and the next image from the same reference. This first drawing of a horse represents a more accurate approach to the mammal and its playful pose.

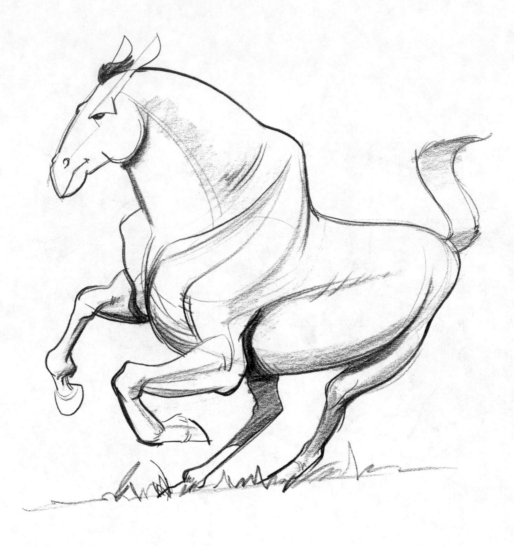

This second image skews the traditional approach of the horse with more opinion. A thicker neck, more robust shoulder region, and thicker forearms create a more muscular and still graceful animal.

ZEBRAS

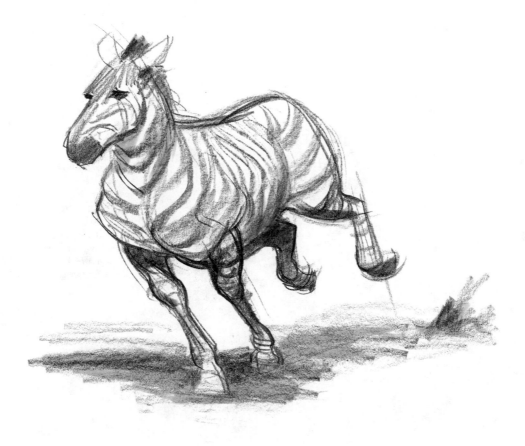

Our first drawing in the zebra section of the book exhibits the common sight of a fleeing zebra. Fortunately for this one, it escaped. Zebras are a joy to draw due to their stripes, which really help define form and their peculiar proportions.

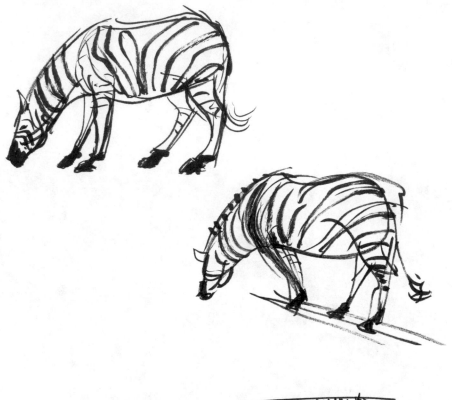

I drew these zebras using a brush pen while at the San Francisco Zoo. The boldness of the pen allowed for quick striping to create form. In the bottom drawing, you can see how I utilized the brush to feel out the FORCE in the shoulder sweeping down into the close front leg.

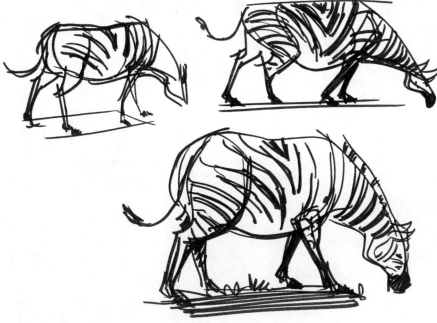

Compared to horses, zebras are more short and stocky. A thick rear end, coupled with short legs, defines the zebras' running-back-like physique. These few quick pen designs present this fine animal. I played with the idea of using a straight line across the entire back, but that concept removes the opportunity for the three-directional FORCES to work with one another. I do like the V-like pattern on the side of the body within the design on the top right.

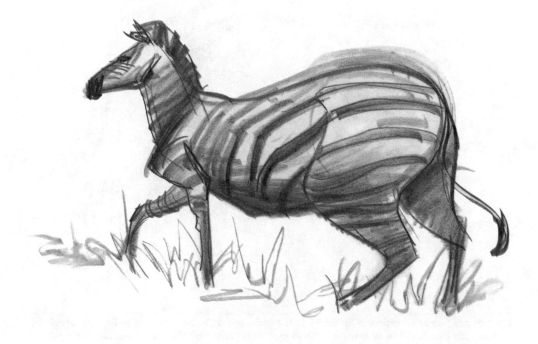

As you can see, I went for the large rump and a short neck with a well-rounded belly for my main concepts during this experience. The zebra also had a somewhat long, thin snout. I pushed the idea of the close front leg feeling like a planted pole. There's not much rhythm there, but that is what the leg felt like to me. I also exaggerated the angularity of the shoulder protruding from the body to clarify its function within the pose.

RHINOS

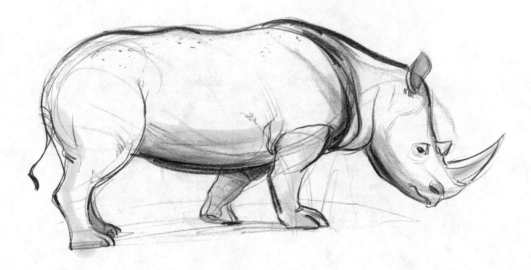

One of my favorite animals to draw is the rhino and, to be more specific, the black rhino. This black rhino is a tank with legs. I went after all the potential power and weight in the front shoulder. The head looks massive and heavy, so I attempted to feel that weight in the neck and bottom of the head. For me, the thought was cradling that head in my hands....what would that weight feel like? How heavy is it? A full-grown adult can weigh over three thousand pounds! Even with all this weight, the rhino can run up to around thirty-five miles per hour. The black rhino is the fourth largest land animal on the planet!.

The black rhino is known to be an aggressive animal. Further research suggests that it has poor eyesight. Due to poor eyesight, the black rhino fears many things and therefore attacks frequently.

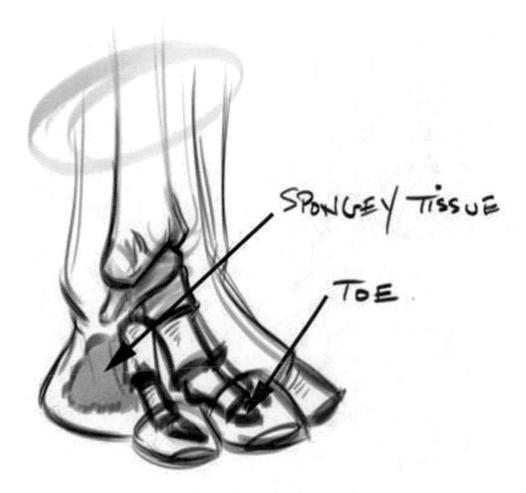

SPONGEY TISSUE

TOE

Personally, I was surprised to discover that rhinos reside in the unguligrade class. I would have guessed digitigrades, especially with elephants falling into that class. Upon further investigation into the foot anatomy, I found that rhinos rest their heels on a spongy tissue similar to the elephant, but the angle of the foot is stronger, which makes the rhino walk more on its toes.

Here is another black rhino. This rhino's design is so pure and clear with its giant tusk on the top of its face. Notice the shape of the prehensile top lip. This triangular form allows the rhino to grab leaves off trees.

This image presents a process from reference to design. In the top-right corner resides a photo I took of a seated white rhinoceros at Safari West. The top drawing is more of a brief study of the pose. Moving through this process allowed me to further understand the FORCES of the rhino in this pose. I executed the bottom design using the knowledge gained from the prior drawing. Both drawings were performed on a Cintiq.

I could not resist. Here is one more drawing inspired by the same photo. I further opinionated the height of the shoulders and pushed out the rear while adding weight there to compress the legs.

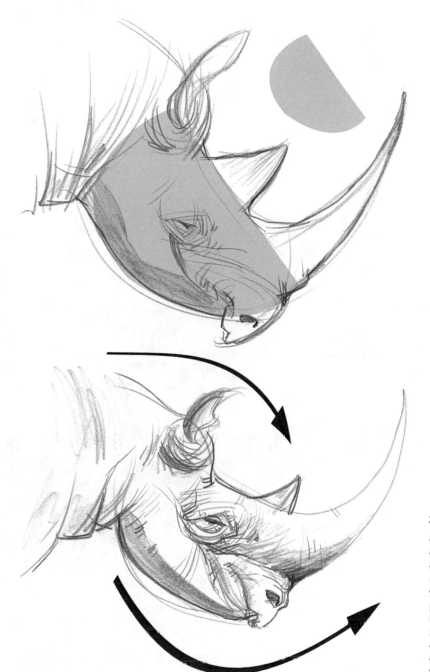

These black rhino heads are two of my attempts at understanding the majesty of the animal. On top is a more shape-oriented approach, and below is one more critical of details. In the top image, the shape of the head ignores the peripheral details, like the horns and its lip. To understand design, you need to see past the details to the bigger shapes and then work hierarchically. Both exhibit the rhythm that I assessed with the two arrows.

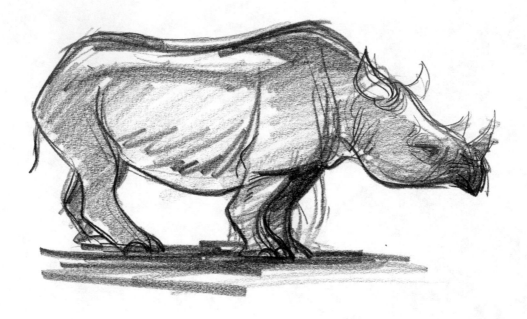

The clear silhouette of the rhino presents the FORCE animal shape. At the end of the shape, I added the weight at the bottom of the rhino's jaw.

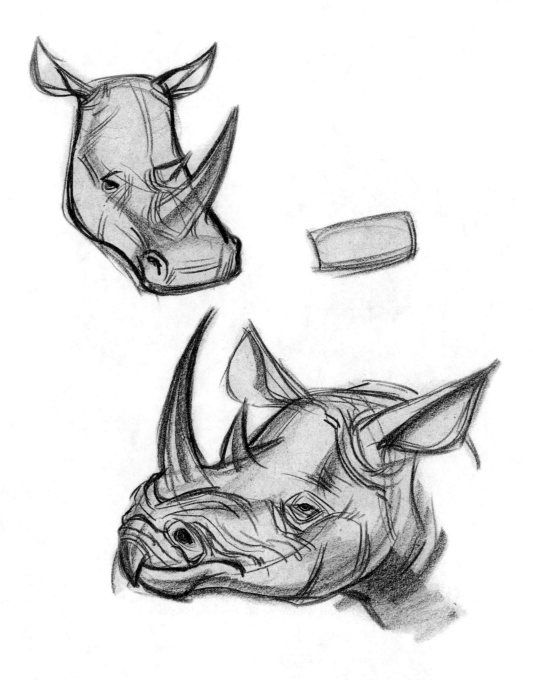

The image above is the white rhino, and the bottom one is black. Both of their muzzles are designed with different shapes to accommodate their diets. The white rhino with a muzzle that looks like a lawn mower eats grass, and the triangular, prehensile lip of the black rhino is used to grab leaves from branches.

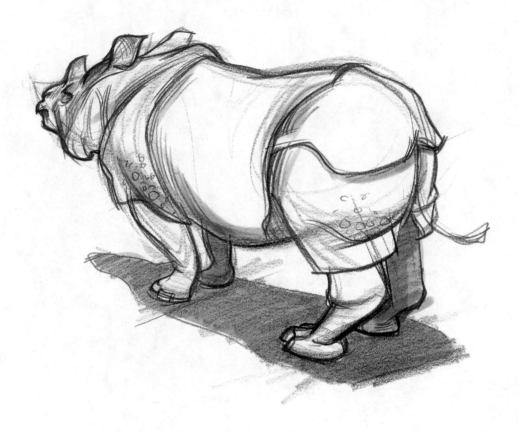

This plated rhino is an Indian rhino. It has only one horn versus the two of the black and white rhinos. The height and weight of the Indian rhino is similar to that of the others.

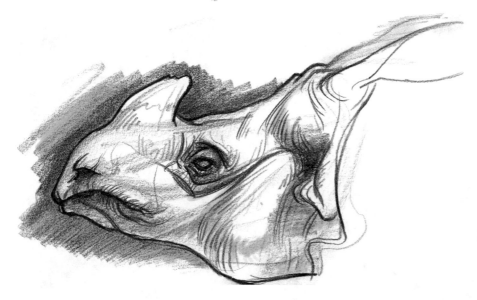

This detail of the Indian rhino head was treated as more of a study. I wanted to better understand how the head was structured with its different folds of skin. The forms are more complex than those on the black or white rhinos.

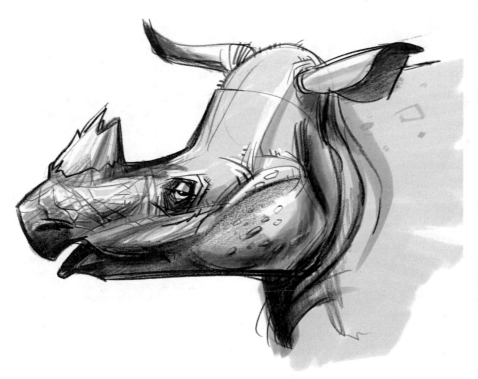

In pushing design on this Indian rhino, I started with a simple silhouette, similar to a lying-down L shape. I slightly thickened the horn and shrunk down the size of the eye. In doing so, the head feels larger. This rhino has a dome-like head and a wrinkled neck. I added some wrinkles for texture and slightly enlarged the cheek area.

The image itself was drawn on paper and then painted in grayscale on a Cintiq.

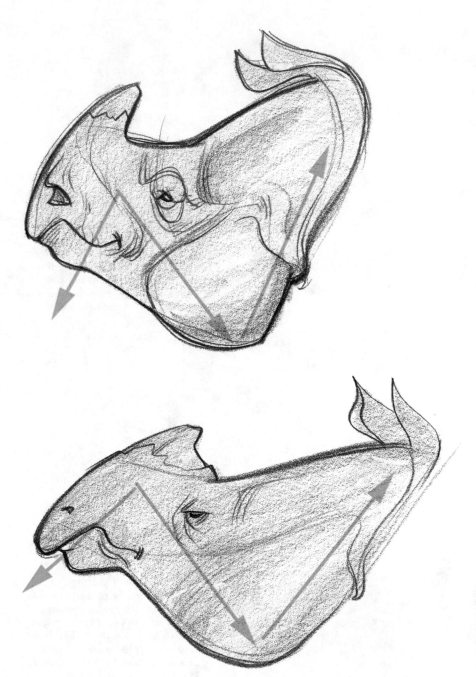

Here are two more Indian rhino head designs. I also started these as simple shapes. The top image is a more horizontally compressed expression of the rhino head. Below, the nose feels as if it has been pulled to the left, creating more open angles of rhythm from the top to the bottom of the head.

EVEN-TOED UNGULATES

Some even-toed ungulates are pigs, peccaries, hippopotamuses, camels, deer, giraffes, pronghorn, antelopes, sheep, goats, and cattle.

DEER

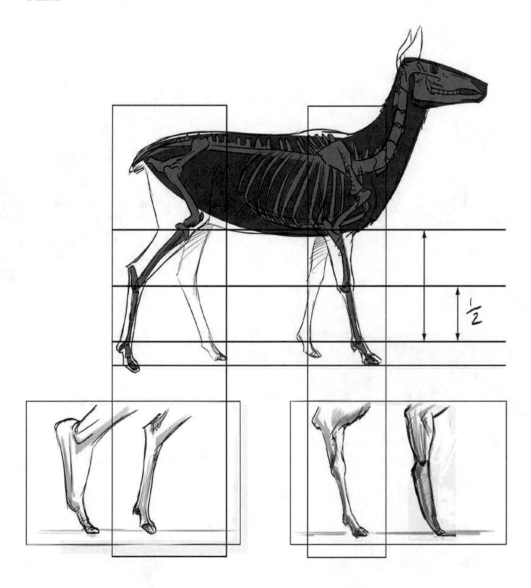

The anatomy of the deer is similar to that of the horse except it has an even number of toes—two in this case.

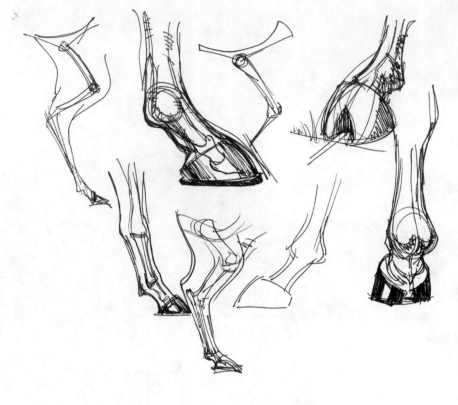

In the top center image, you can see the bone structure of the hoof region. These joints represent the knuckles found in human fingers and toes. See the split in the hoof called a cloven hoof, representing two toes.

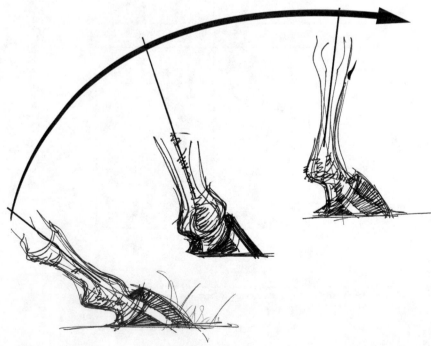

In this image, you can see the joint that represents the pad of the hand presenting its range of motion.

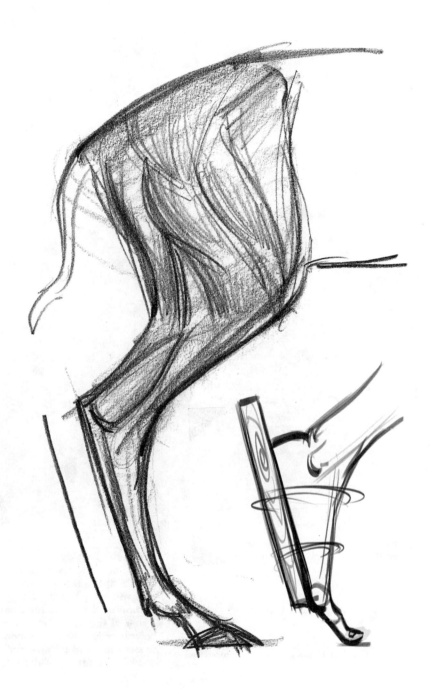

The deer's "heel" makes obvious the extension of the bone beyond the top, back of the foot. It is as if the bottom of our foot had a long piece of wood tied to it, and this piece of wood extended past our heel.

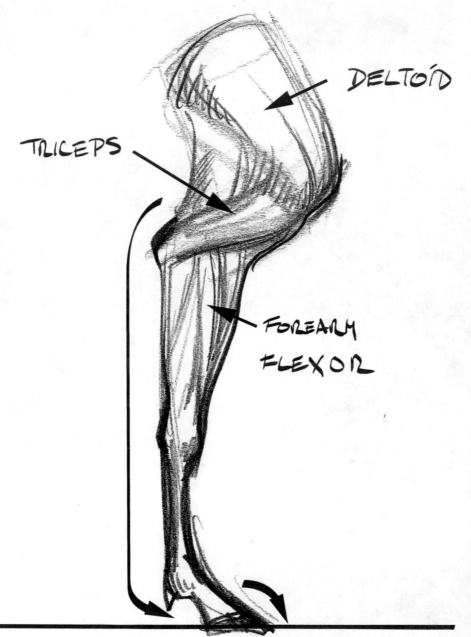

DELTOID

TRICEPS

FOREARM FLEXOR

Here is the foreleg of the deer. I designed callouts for the **FORCES** of the leg and the large muscle groups. The function of the leg is the same as any of the other ungulates. The canter levering between the deltoids and triceps makes possible the lifting of the leg.

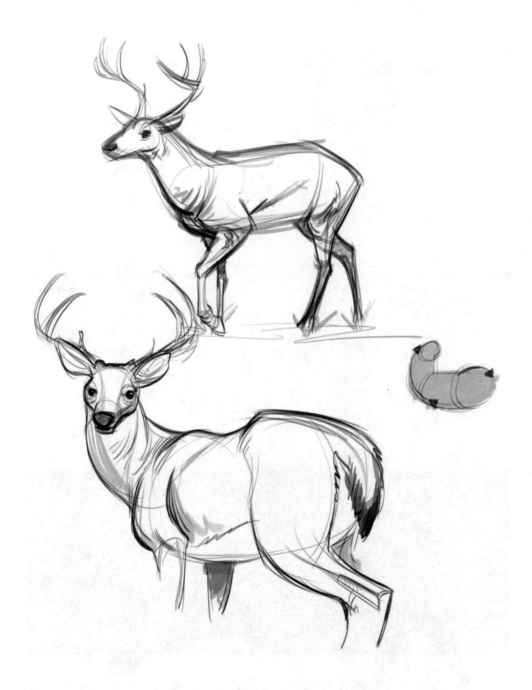

Here are some quick sketches of two deer. For the bottom deer, I roughed out the long, curved **FORCE** of the body and filled in the shape for you to see my process. With the deer curled up from this angle, you can simplify the function of the deer's **FORCES.**

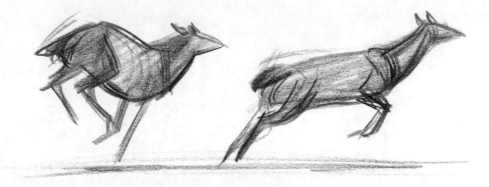

Here are two moments found in the running gait of this deer. Figuring out the gait of any animal is made easier through the use of the silhouette. Notice the compression in the first image on the left. Then the deer springs out of this pose and in the last prepares again for the landing that will allow it to spring forward again.

Elk

Elk are one of the largest species of deer in the world. This powerful elk walks through the high grass, enjoying its lunch. Thick shoulder and neck muscles help support its antlers.

Above is my opinionated version of the elk, bringing forth features I find to define the character of the elk. I enlarged the shoulder region and its muscularity. I also increased the size of the abdomen. In addition, I stretched and narrowed the muzzle and thinned out the rear legs. The thin legs further exaggerate the massive torso.

ANTELOPES
Hartebeest

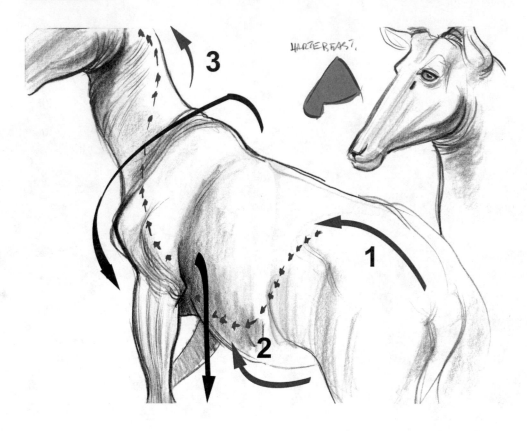

In this image, you can see the pathways of FORCE through the hartebeest. The larger arrows represent directional FORCE, and the smaller are applied FORCES. The shape in the top right represents the head of the animal.

Sable Antelope

The top drawing contains a small shape in the bottom-right corner identifying the fluid design of the neck and head found in this sable antelope. Below is a diagram of the FORCES found in the neck, head, and ear of the antelope. Notice the design of the ear and how its shape represents its function by pushing itself forward and upward to open itself up to the sounds found in its surrounding environment, similar to a radar dish.

Gemsbok

The gemsbok is thick and stocky with interesting and well-designed markings. They are from Africa, but I had the good fortune of drawing this one in the Northern California hills at Safari West.

Goat

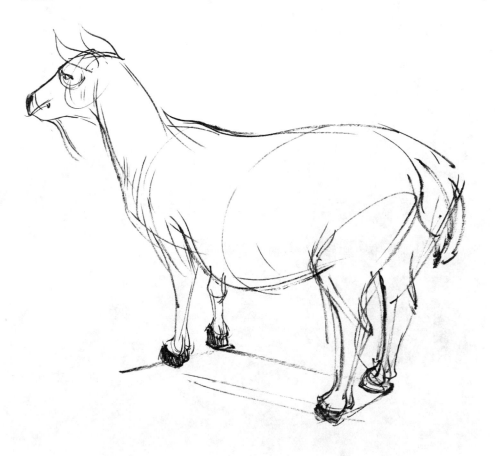

This beer-bellied goat was in the children's area of the San Francisco Zoo. He is far from underfed with all the eager children buying pellets from old gumball machines. His weight is evenly distributed among his four legs. I put one line around the perimeter of his midsection to remind myself of how round he is.

Bull

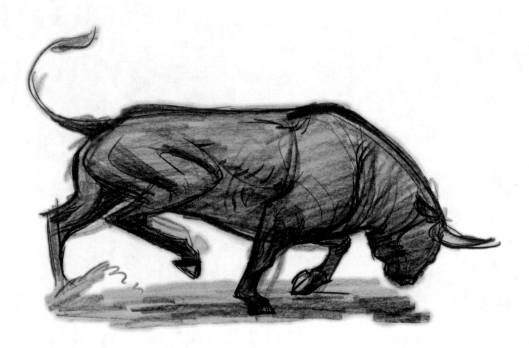

This charging bull leans his mass forward as back legs pump, prepared for the charge. Clear forceful shapes define this powerful animal. Notice the parallel lines in the thigh and foot of the back leg and the shoulder and forearm of the front.

Cape Buffalo

These three cape buffalo drawings show how I sometimes progress through designs. The top image is the most realistic, but at this first pass, I have already started to illustrate opinions. You can see the enlarged nose and muzzle, thick body, and small legs. For the middle image, I horizontally stretched the head, the muzzle, nose brow, and horns. The body shape was my focus for the last or bottom design. I played with the vertical height of the body, the thickness of the horns, small eyes, and large nose.

Addax

ADDAX
ANTELOPES.

The Addax antelope comes from the Sahara Desert as an endangered species. It is known for its corkscrew antlers. This image shows a reclined Addax. See how the arms and legs fold up under the body, and yet the FORCE animal shape still flows through the body and into the neck and head.

Kudu

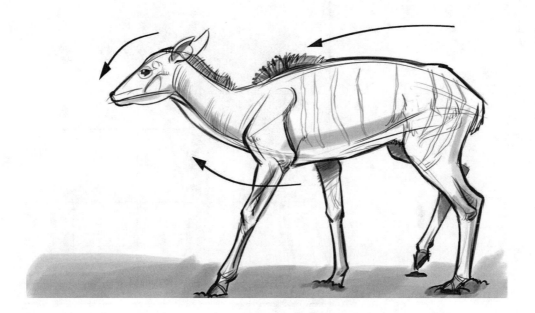

This female kudu has a streamlined body demonstrating the three main FORCES of the FORCE shape. You can see how it is in stride since the far back leg is on its way to kick the front far leg forward. The male kudu also has corkscrew antlers.

GIRAFFES

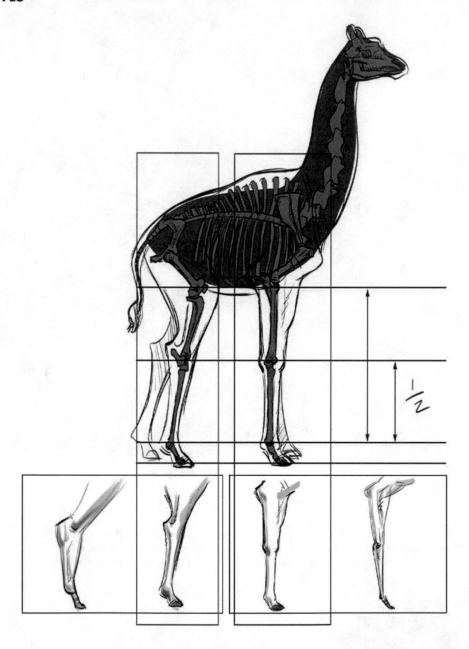

I truly enjoy my drawing experiences of giraffes. Years ago, I ran private, summer drawing classes. One week I met students at the Bronx Zoo. At the time, I had not seen a live giraffe for about fifteen to eighteen years. My class and I were walking through the zoo and rounded a thickly wooded corner when we entered a small viewing area to the giraffe exhibit. My first impression of these amazing animals was that I was watching modern-day dinosaurs walking the earth, right in front of my eyes.

Before we move on, remember that in Chapter 2 on the plantigrades, I mentioned the large thoracic vertebrae in the giraffe. Notice the long bones protruding from the spine, hiding behind the scapula. They cause the large hump that contributes to the peculiar silhouette of the giraffe.

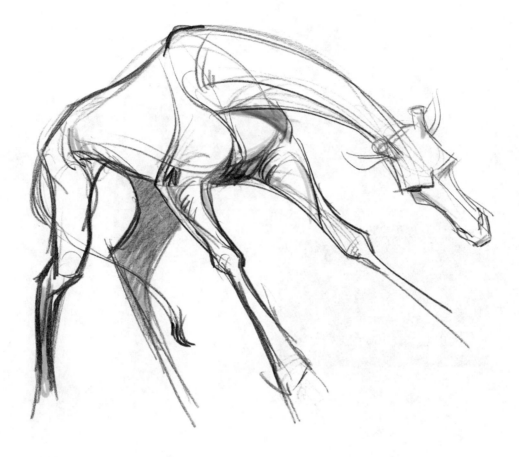

This giraffe fought another using his long legs and neck. His lean, triangular body pulled backward as he prepared to swing his neck against his opponent. Male giraffes use the horns on their heads as weapons in combat with great accuracy and devastating power.

While creating this drawing, I compared the giraffe's anatomy to humans during the exploration of the forearms and the thighs. Even now, as I look at this image, I can see that comparison.

Due to the height of giraffes, it is difficult to get a true sense of the size of their head. My first trip to Safari West took care of this. My wife and I visited on a cool day filled with a soft and constant drizzle falling from the gray sky. The weather did not affect our trip relative to viewing the animals, but I kept thinking how beautiful the landscape would look with a blue sky and some white, puffy clouds overhead. Well, at the end of our tour, our guide led our group into the Giraffe Barn, which is where most of the giraffes stay when it is raining. I guess they don't like getting wet. Either way, I happened to be at the front of the line walking into this barn. There were long, narrow, and tall hallways to travel, and at the end of one, on the left side, high off the ground was a giraffe's head focused in my direction. I slowly walked down the hall with the rest of the group close behind. The guide finally passed me to gain the front position. Suddenly, the giraffe brought its head down to greet him. The giraffe's head lay suspended within inches of my face. I was amazed at just how large this exquisite animal was. It had immense, softball-sized eyes with finger long eyelashes. I made my way under it as it raised its head. My wife, Ellen, then stood where I had been, and the giraffe came down to her and licked her ear and neck with its long purple tongue. Priceless footage. We both left that day thankful for the rain and amazed by nature and the raw beauty of the animal kingdom. That was a day I will never forget.

This second giraffe head drawing brings attention to the abundance of straight to curve or forceful shape design. At the top of the pyramid of shapes lies the overall head shape in the lightest gray tone. Then you can see the chin, ears, horns, and eye are also born from the same shape. Lastly, in the darkest gray tone, I point out a smaller portion of the ear and its shape design. All this thinking occurs as I am drawing. I decide how graphic or organic I want my drawing experience to be.

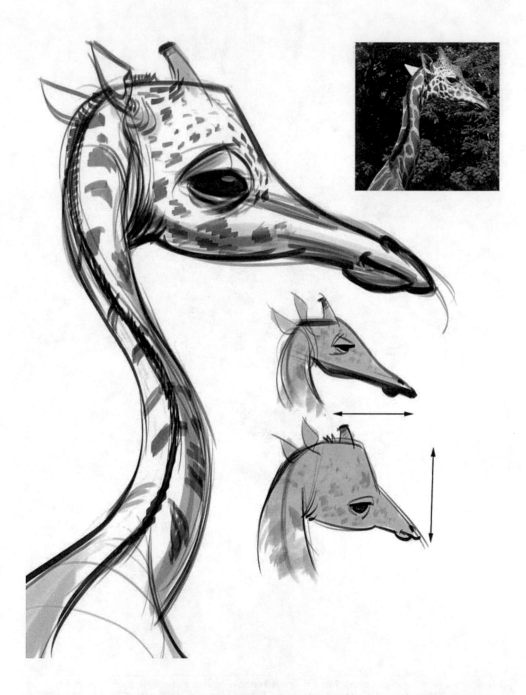

Another photo from my Safari West visits inspires the creation of the designs found here. The large image was driven by the fluidity found within the neck and head. On the right, the two thumbnails transpired from the simple process of stretching the giraffe head vertically or horizontally.

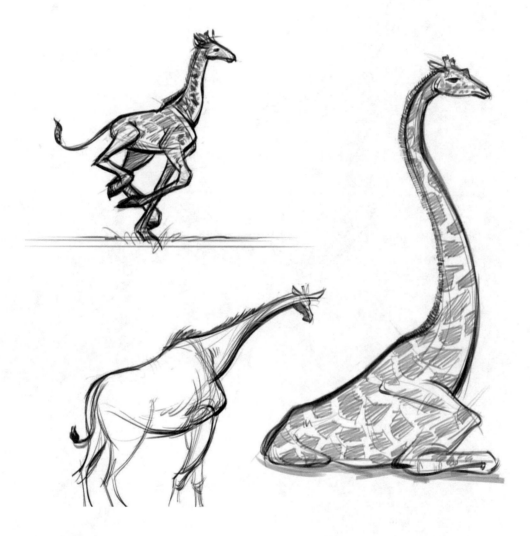

Here are some full body illustrations of the giraffe. The top-left image is not too far from reality since it is based off a young giraffe. Its neck is shorter and its legs are proportionately thicker relative to the body than those of an adult.

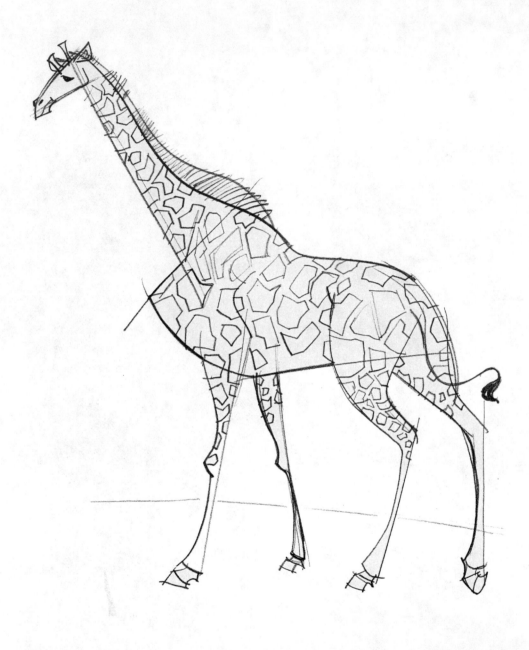

This chapter ends with a design of the giraffe. I focused on some of its distinguishing traits. I pushed out the front of the chest and extenuated the long, thin legs.

For the last chapter, I will focus on design.

Chapter 5
Animal Design

In this chapter, we will look further into forming opinions on the animals we have covered from previous chapters. I will describe a useful visual tool to assist with this manner of assessment.

THE LAW OF THIRDS

The law of thirds is a crucial design law. The box on the left shows no divisions. The second box shows a halfway division. This immediately causes symmetry. That means the top and bottom of the box or the figure are the same. It is this sameness that we are trying to avoid in our work. Our minds want to create symmetry, and the irony is that this symmetry causes disinterest in art. Remember, contrast creates interest. So, that leads us to our third box on the right. Here, I have divided the image into thirds!

See Plate 1 in insert for color version.

Now I have taken our box that is split into thirds in its vertical height and in the second image split it in half from left to right. This waters down our design again. In the last image, we have the iconic image of design in thirds; our rectangle is divided in thirds, both vertically and horizontally. **Remember this image!**

See Plate 2 in insert for color version.

This image shows our iconic box on its side. You can use the rectangle this way also. The horizontal grid is great for the animal kingdom since most animals are more horizontal than vertical.

See Plate 3 in insert for color version.

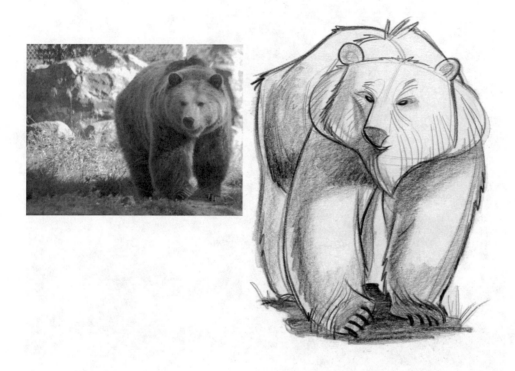

Here is a grizzly I photographed at the San Francisco Zoo. Due to its thick fur, it was fairly easy to simplify the shapes of the animal. I made sure to catch the gesture of the bear's front paw in mid-stride.

See Plate 4 in insert for color version.

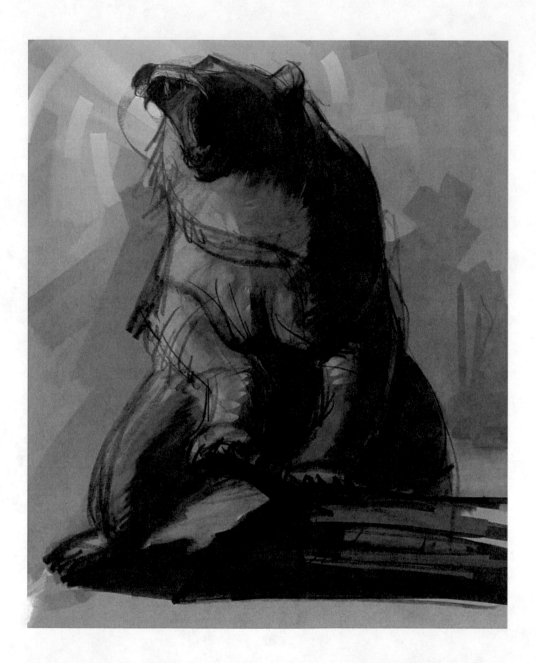

An angry grizzly stands at eight feet tall, bellowing out in rage. He leans on a fallen tree. I accentuated the bellow by placing the lightest color near his mouth, forcing your eye to focus there. I also painted the background in loose concentric circles with the head as the center.

See Plate 5 in insert for color version.

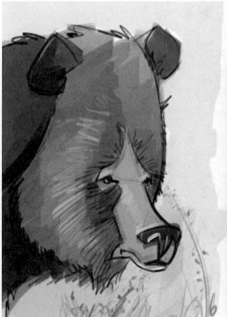 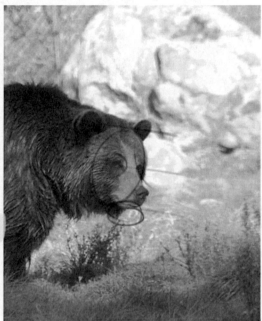

Above is a reference photo of a grizzly taken at the San Francisco Zoo. Notice in the photo that the bear's face is naturally split in half, from top to bottom. To the left is a design for which I show the process on my site (www.drawingforce.com). I started this design with a long vertical ellipse. This was obtained by using the abstract system of thirds found at the beginning of the chapter. I then shrunk down the eyes but made the closer eye larger for a sense of depth. Then I clarified the sweep of the nose bridge and the arc of the nose top. All of this then received a quick paint job on the Cintiq. The grass was added to bring further focus to the bear's face.

See Plate 6 for color version.

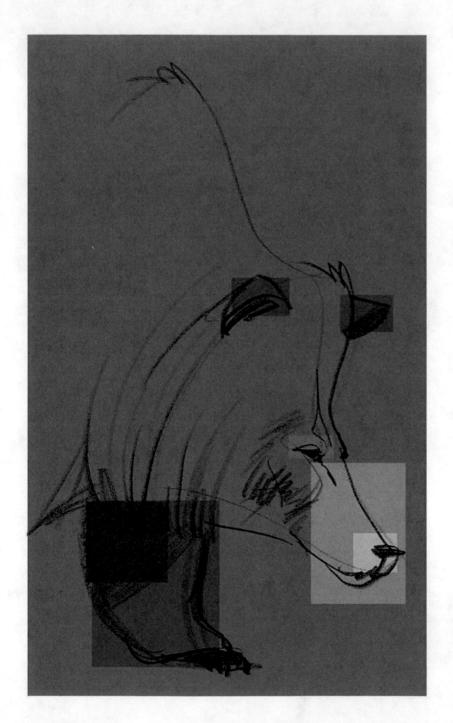

This grizzly exaggerates the vertical height of the head and the horizontal length of the snout. Color is used to bring focus to the design. The priorities I defined are the general vertical shape of the design, the nose of the grizzly, and then the eye.

See Plate 7 in insert for color version.

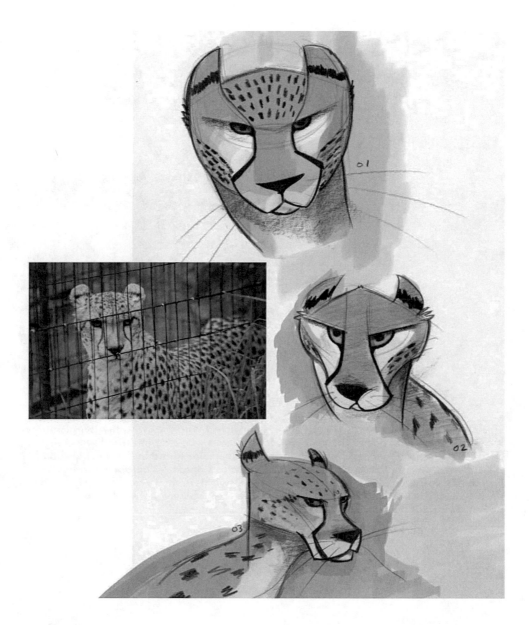

My approach in the above cheetah designs comes from a place of graphic flatness, more so than the other cheetah drawings. I observed the interesting shape created by the black lines that ran from the eyes, down the sides of the nose, and around the muzzle. The bottom-most drawing has more volume. Here I gave the cheetah a strong, squared-off jaw and a large nose. The reference photo was taken at Safari West.

See Plate 8 in insert for color version.

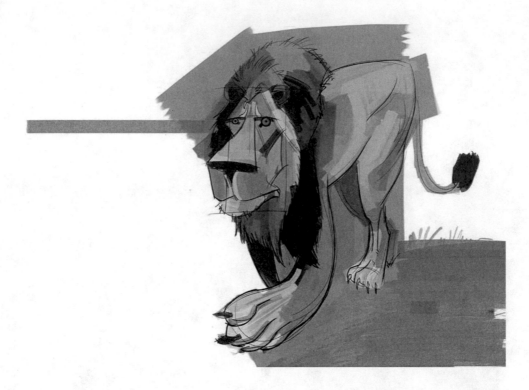

This male lion walks along, alone, looking for prey. I was drawn to the long face and large flat nose, along with the swinging front paw. I was also intrigued with the circular quality of the eyes. I played up the orange color found in the eyes and added a horizontal design element to bring attention to this detail. To balance out the horizontal orange line, I placed a small orange swatch in the grass to the right. The dark hair of the lion's mane helps surround the face. I placed light colors on the front paw to bring it attention and to bring it forward in space.

See Plate 9 in insert for color version.

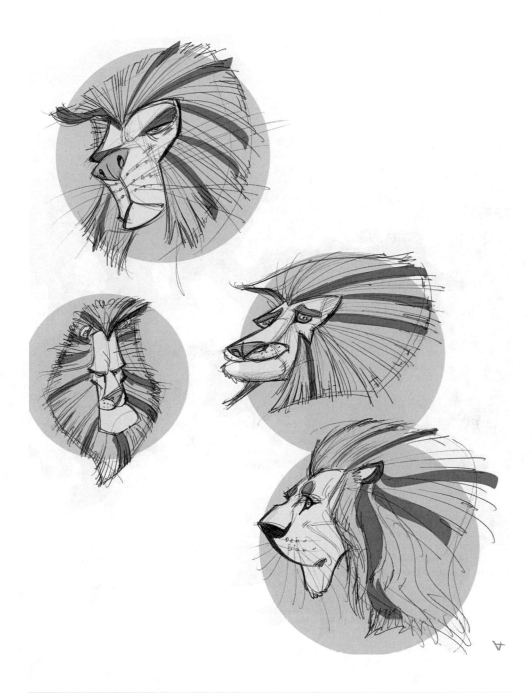

Above are iterations of the lion head. By stretching proportions, I have developed faces that present different types of characters.

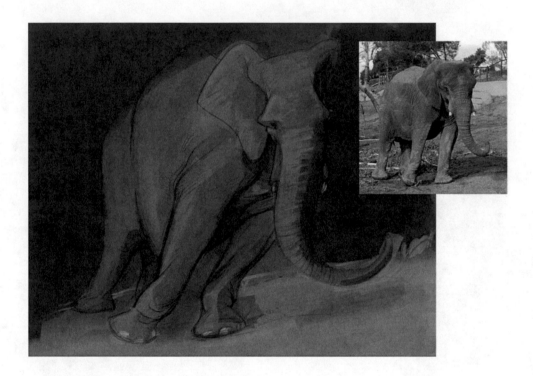

This elephant is found earlier in Chapter 3 on digitigrades. I pushed an orange quality into the elephant's skin to contrast it against the greens of the background. Again, I used a blue swatch to balance the blues found in the elephant's shadows. You can see from the reference how I pushed the idea of the elephant leaning to the right. The reference photo was taken at the Oakland Zoo.

See Plate 10 in insert for color version.

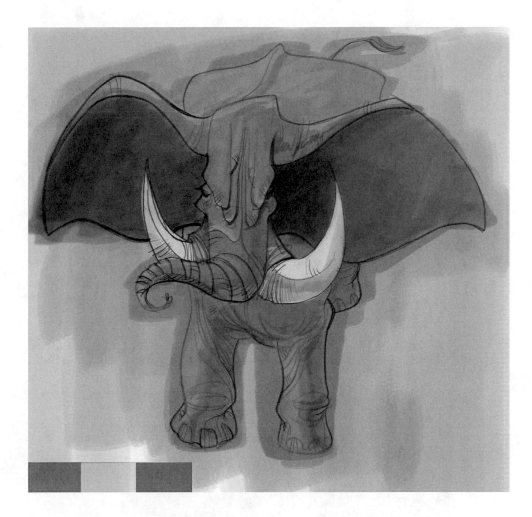

By using the colors of the Ethiopian flag, I imbue this design with more meaning. Two concepts that could be extracted are:

1. Stop the murder of elephants for their tusks.
2. This is one angry elephant. Stay away.

What causes these impressions? Well, for me, it is the hot red color. Red is usually equated with anger or blood. Color, orientation, and design all contribute to your ideas. Everything matters in an image. Keep this concept in mind while creating your own.

See Plate 11 in insert for color version.

This African elephant design is illustrated with line, form, and shape. The color shapes are used to insinuate simple forms by using browns with few different tones.

See Plate 12 in insert for color version.

Here is a wolf I painted. The choices of purple and yellow felt right although I was not sure why, but when I look back on this experience, it reminds me of evening hours with moonlight. I paid most attention to the face and therefore placed the highest contrast there. The blurred lines signify speed. I exaggerated the size of the wolf's nose and the length of his muzzle. His paws are long and sinewy.

See Plate 13 in insert for color version.

I took the sable antelope and instilled his design with the character of a bully. The downward-turned nose mimics that of a boxer. The angry brow line and mouth along with the muscular shoulders and chest accentuate the bully concept. The red background is the final touch to further present his rage.

See Plate 14 in insert for color version.

Here I focused on just the head of the sable. Proportion drove the different concoctions. In the left-most image, I stretched the top, vertical section of the head and shrunk its scimitar-shaped horns. The top-right drawing has vertically extended horns and somewhat evenly proportioned vertical and horizontal head shapes. In the bottom image, I stretched the muzzle of the sable and shortened the top portion of its head. I made the ears and eyes in all three images very small.

See Plate 15 in insert for color version.

Here is a more graphic representation of the sable antelope. This image was created in Photoshop using the Pen tool. Defining shapes based on points and curves is a tricky process. The process allows for no error, but the finished product is clear and compelling.

See Plate 16 in insert for color version.

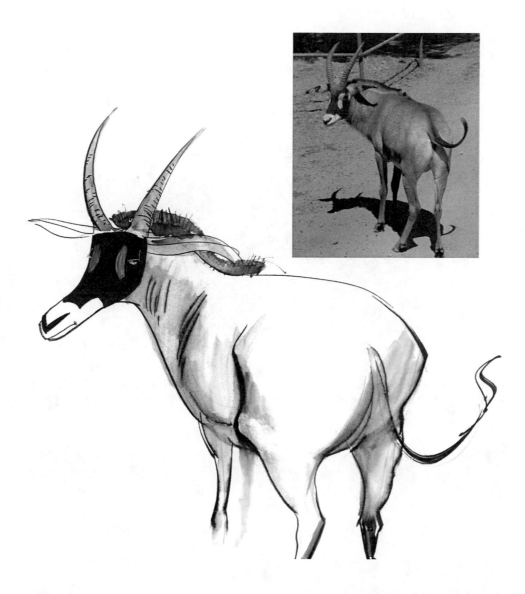

I am always amazed at nature and how beautiful it is. Not only are we observing a wonder of chemistry and anatomy, but nature goes a step further with amazing colors and graphics based on the functionality. This Roan antelope wears a wonderful black and white mask and a nice creamy coat over its body. Here, it was standing in front of the jeep my family and I were riding in at Safari West.

See Plate 17 in insert for color version.

I grew up with many pets and my mother's deep admiration for animals. "A life is a life," she always said. Due to this expression, I have developed a fond respect for the animal kingdom.

I close this FORCE animal drawing and design book with a photo of my family alongside a Safari West jeep.

I hope that with the closing of this book you will develop a deeper understanding of and admiration for the animal kingdom through the act of drawing with the concept of FORCE. Enjoy!

References

I used numerous types of reference for the creation of this book. Of course, as always, real life is the best reference. I drew the images found in this book from zoos, friends' pets, documentaries on TV and YouTube, DVDs, books, Internet images, magazines…the list goes on. Anywhere that I could find inspiration, I was happy to use it. My trips to the Oakland Zoo, San Francisco Zoo, and Safari West produced rich family time mixed with work. Go and support your local zoo, get to know the animals there, and take a friend.

Following are some of my favorite artists who draw animals as part of their subject matter:

Terryl Whitlatch—Creature Designer and author of *Animals Real and Imagined*.
Frank Frazetta—The king of fantasy illustration
Heinrich Kley—German satirist—great loose ink drawings
Glen Keane—One of Disney's top animators
David Coleman—Character designer and story artist for the animation industry
Joe Weatherly—Fellow animal drawing instructor and author
Al Severin—Belgian comic book artist—amazing fluidity
Claire Wendling—French comic book artist—also amazing fluidity
Ken Hultgren—Author and illustrator of one of the better animal drawing books; former Disney artist from the 1940s
W. Ellenberger—Author of an excellent reference for animal anatomy
Charlie Harper—American modernist, graphic style illustrator
Andrew Shek—great blog—elephantart.blogspot.com—designer for animation industry

Index

Note: Page number followed by f indicate figures.

Plate 1 The law of thirds is a crucial design law. The box on the left shows no divisions. The second box shows a halfway division. This immediately causes symmetry. That means the top and bottom of the box or the figure are the same. It is this sameness that we are trying to avoid in our work. Our minds want to create symmetry, and the irony is that this symmetry causes disinterest in art. Remember, contrast creates interest. So, that leads us to our third box on the right. Here, I have divided the image into thirds!

Plate 2 Now I have taken our box that is split into thirds in its vertical height and in the second image split it in half from left to right. This waters down our design again. In the last image, we have the iconic image of design in thirds; our rectangle is divided in thirds, both vertically and horizontally. Remember this image!

Plate 3 This image shows our iconic box on its side. You can use the rectangle this way also. The horizontal grid is great for the animal kingdom since most animals are more horizontal than vertical.

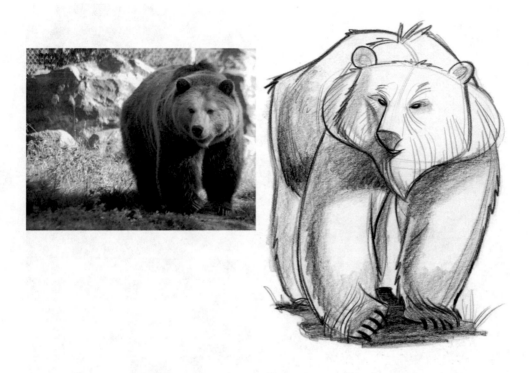

Plate 4 Here is a grizzly I photographed at the San Francisco Zoo. Due to its thick fur, it was fairly easy to simplify the shapes of the animal. I made sure to catch the gesture of the bear's front paw in mid-stride.

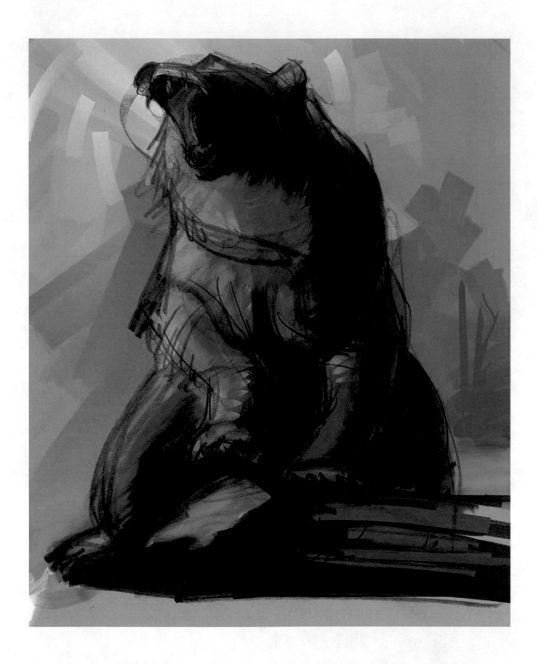

Plate 5 An angry grizzly stands at eight feet tall, bellowing out in rage. He leans on a fallen tree. I accentuated the bellow by placing the lightest color near his mouth, forcing your eye to focus there. I also painted the background in loose concentric circles with the head as the center.

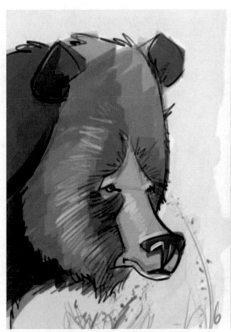 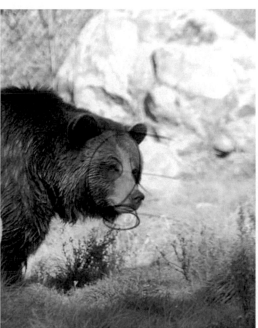

Plate 6 Above is a reference photo of a grizzly taken at the San Francisco Zoo. Notice in the photo that the bear's base is naturally split in half, from top to bottom. To the left is a design for which I show the process on my site (www.drawingforce.com). I started this design with a long vertical ellipse. This was obtained by using the abstract system of thirds found at the beginning of the chapter. I then shrunk down the eyes but made the closer eye larger for a sense of depth. Then I clarified the sweep of the nose bridge and the arc of the nose top. All of this then received a quick paint job on the Cintiq. The grass was added to bring further focus to the bear's face.

Plate 7 This grizzly exaggerates the vertical height of the head and the horizontal length of the snout. Color is used to bring focus to the design. The priorities I defined are the general vertical shape of the design, the nose of the grizzly, and then the eye.

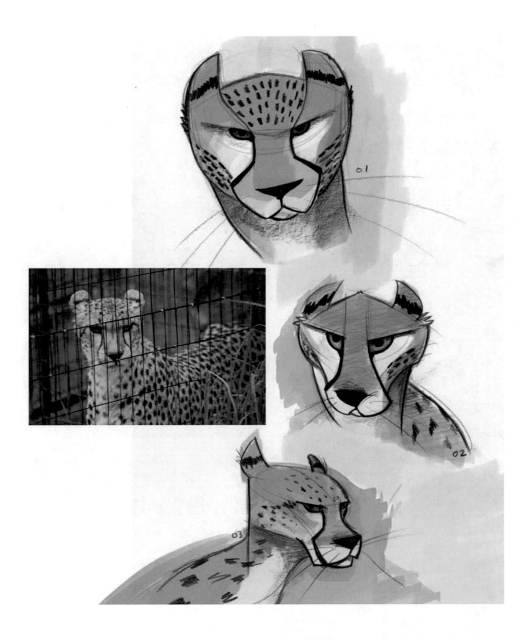

Plate 8 My approach in the above cheetah designs comes from a place of graphic flatness, more so than the other cheetah drawings. I observed the interesting shape created by the black lines that ran from the eyes, down the sides of the nose, and around the muzzle. The bottom-most drawing has more volume. Here I gave the cheetah a strong, squared-off jaw and a large nose. The reference photo was taken at Safari West.

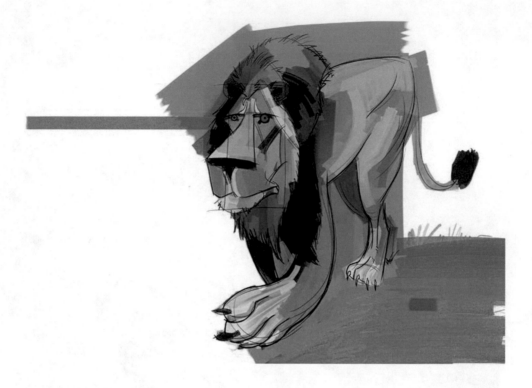

Plate 9 This male lion walks along, alone, looking for prey. I was drawn to the long face and large flat nose, along with the swinging front paw. I was also intrigued with the circular quality of the eyes. I played up the orange color found in the eyes and added a horizontal design element to bring attention to this detail. To balance out the horizontal orange line, I placed a small orange swatch in the grass to the right. The dark hair of the lion's mane helps surround the face. I placed light colors on the front paw to bring it attention and to bring it forward in space.

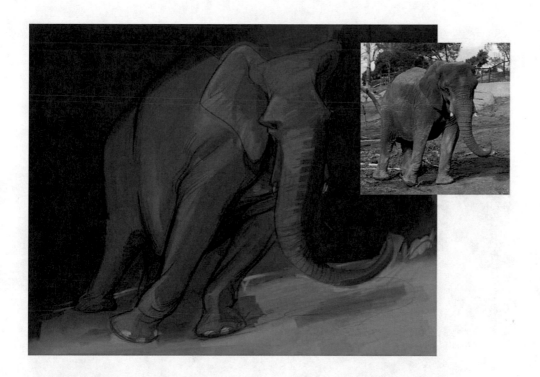

Plate 10 This elephant is found earlier in Chapter 3 on digitigrades. I pushed an orange quality into the elephant's skin to contrast it against the greens of the background. Again, I used a blue swatch to balance the blues found in the elephant's shadows. You can see from the reference how I pushed the idea of the elephant leaning to the right. The reference photo was taken at the Oakland Zoo.

Plate 11 By using the colors of the Ethiopian flag, I imbue this design with more meaning. Two concepts that could be extracted are:

1. Stop the murder of elephants for their tusks.
2. This is one angry elephant. Stay away.

What causes these impressions? Well, for me, it is the hot red color. Red is usually equated with anger or blood. Color, orientation, and design all contribute to your ideas. Everything matters in an image. Keep this concept in mind while creating your own.

Plate 12 This African elephant design is illustrated with line, form, and shape. The color shapes are used to insinuate simple forms by using browns with few different tones.

Plate 13 Here is a wolf I painted. The choices of purple and yellow felt right although I was not sure why, but when I look back on this experience, it reminds me of evening hours with moonlight. I paid most attention to the face and therefore placed the highest contrast there. The blurred lines signify speed. I exaggerated the size of the wolf's nose and the length of his muzzle. His paws are long and sinewy.

Plate 14 I took the sable antelope and instilled his design with the character of a bully. The downward-turned nose mimics that of a boxer. The angry brow line and mouth along with the muscular shoulders and chest accentuate the bully concept. The red background is the final touch to further present his rage.

Plate 15 Here I focused on just the head of the sable. Proportion drove the different concoctions. In the left-most image, I stretched the top, vertical section of the head and shrunk its scimitar-shaped horns. The top-right drawing has vertically extended horns and somewhat evenly proportioned vertical and horizontal head shapes. In the bottom image, I stretched the muzzle of the sable and shortened the top portion of its head. I made the ears and eyes in all three images very small.

Plate 16 Here is a more graphic representation of the sable antelope. This image was created in Photoshop using the Pen tool. Defining shapes based on points and curves is a tricky process. The process allows for no error, but the finished product is clear and compelling.

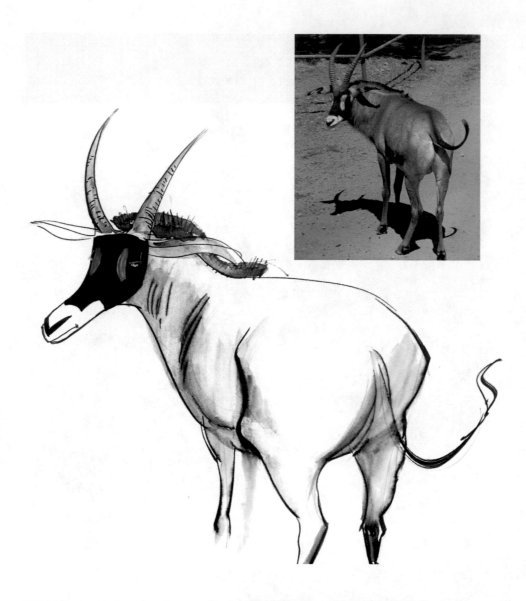

Plate 17 I am always amazed at nature and how beautiful it is. Not only are we observing a wonder of chemistry and anatomy, but nature goes a step further with amazing colors and graphics based on the functionality. This Roan antelope wears a wonderful black and white mask and a nice creamy coat over its body. Here, it was standing in front of the jeep my family and I were riding in at Safari West.